Pregnant Goddesshood

A CELEBRATION OF LIFE

Mary Ann Halpin

Publisher: W. Quay Hays
Editorial Director: Peter Hoffman
Editor: Amy Spitalnick
Art Director: Susan Anson
Production Director: Trudihope Schlomowitz
Color and Prepress Director: Bill Castillo
Production Artist: Regina Troyer
Editorial Assistant: Dana Stibor
Production Assitants: Tom Archibeque, David Chadderdon, Gus Dawson

For information:
General Publishing Group, Inc.
2701 Ocean Park Boulevard, Suite 140
Santa Monica, CA 90405

Library of Congress Cataloging-in-Publication Data

Halpin, Mary Ann
 Pregnant Goddesshood : a celebration of life / by Mary Ann Halpin
; foreword by Marcelene Dyer.
 p. cm.
 ISBN 1-57544-028-8
 1. Pregnant Women. 2. Pregnant Women — Pictorial Works
3. Pregnancy — Psychological aspects. I. Title.
HQ759.H187 1997
155.6'463 — dc21

 97-18384
 CIP

Printed in the USA
by RR Donnelley & Sons, Inc.
10 9 8 7 6 5 4 3 2 1

GENERAL PUBLISHING GROUP
Los Angeles

Ode to a Baby

New Spirit
Fragile, strong
Child floating on the breath of God
Welcome...Teacher of all...Honored soul
Walk your path...Learn
Feel the Earth's story
Child of the new millennium...Show us how
Play your song of beauty...God-Goddess new
Love...Embrace all
Hold to you own truth
Your moment...Your voice...Word...Power
Life will lead you...Trust it
You are that...Pure light
Baby

This book is my baby. In 1991, I began photographing a series of fine art portraits of women for a gallery showing. My first subject was a pregnant woman. How extraordinary she was to reveal her swollen body for the camera...so full of baby. She exuded a goddess-like glow. Little did I know what an amazing adventure I was about to begin.

My art has always been a reflection of my life. This book presented a journey for me to reconcile my deepest emotional and spiritual feeling about pregnancy, birth, and motherhood. It touched my life and everyone associated with it in the most profound way. I met women who shared so much of themselves. I discovered a philosophy that connects all the women in this book on a very deep level. Every one of them found the path to my studio in a very mystical way. I remain in awe of their strength, beauty, and humor.

My greatest gift was to experience two births. Laura Robinson Ettlinger was in labor when I photographed her in her garden. Two hours later, she birthed Julia in a water tank in her bedroom. How magical to witness this miracle. I joined Gosia and Marek Probosz in the last 20 hours of labor. To share in the ritual of labor with Gosia and her midwife was extraordinary. Looking back, I don't know how I took pictures with Gosia's right foot on my shoulder. The moment of Valentina's birth was exhilarating—and surreal.

I am so grateful to all of my pregnant goddesses, who by now are goddess moms. Every one of these women taught me so much about myself and showed me a part of life I would have never experienced without her.

So, I continue in the goddesshood, photographing my journey as the celebration of life continues...

—Mary Ann Halpin, 1997

Foreword

By Marcelene Dyer

If you have merely glanced at a few pieces of Mary Ann Halpin's art photography in this book, you can understand why I immediately said "yes" to her sweet request that I write the foreword to her book. I am thrilled and honored to share my thoughts with you.

Birthing seven children into this world is my greatest accomplishment. Regardless of what else I may achieve, becoming a mother is my true purpose. For me, the root of creation is the family. As we give birth to our children, we are giving birth to the world. Think of it! Our combined efforts toward a better world—one of peace, harmony, freedom, shelter, and sustenance for all—must start somewhere as we enter the third millennium. Clearly, to begin with creation—the birth of our children—is the optimum commencement.

As I look into my children's eyes with a mother's love, I know they are receiving their greatest nourishment. A mother is a child's first teacher. I believe her love is the connection to the love of God. She has this divine responsibility bestowed upon her. What an honor!

Never doubt your role as parent. We need to return to the simple act of nurturing each other. Love is all that we have to give, and it is our one true need.

Simply look into the eyes of the women portrayed in this book. These women have surrendered to the divinity of their motherhood. They are inspiring. Purposeful. Radiant. I cannot help smiling as I gaze at each exquisite photo.

One woman's name repeatedly enters my mind: Demi Moore. I doubt she could ever know how much worth she returned to us in our pregnant bodies. The cover of *Vanity Fair*, with Moore's breathtaking, pregnant beauty shown in all its glory, captured the world.

Now, Mary Ann's creative work takes us further. On each page, she has captured the embodiment of feminine power. The images are fearless and completely intimate. Silent, yet resonant with all that is. A clarity so explicit, we are caught up, magically, in awe.

How far we have come. Once, not so long ago, pregnancy was hidden. We dressed to conceal our swelling bodies. We even showed embarrassment. This was a time of "confinement." I remember vividly on a Maui beach the day I saw a bikini-clad woman in her eighth month of pregnancy. I watched her walk toward me, and I watched her walk away. Wow! She was celebrating God's gift to her. I felt she was clearly saying, "I am in a woman's body, in a natural state of pregnancy, and I am proud." It is time. Yes, it is time.

Mary Ann and her pregnant goddesses are our pioneers for this passage. As I mother my own seven children, I am purposeful that they become part of the solution and not the problem. As we awaken to our responsibilities in mothering, may we see with clearer eyes and purer hearts. It is never about the outer world. That conception happens inside us, that the development from embryo to fetus is within lays the foundation for our own inner work—that our answers are also within.

Mary Ann herself has never given birth to a child. In fact, she is adopted—the connection to her birth mother severed. Yet in every one of these photos, Mary Ann's love gloriously beams back at us. She is our mother of the photographic art of pregnant goddesshood.

Kneeling in prayer at my altar, I pray to the Mother, Father, and God of all that this be a time of awakening and healing here on earth. Let us look into one another's eyes and embrace with our hearts. I offer a prayer of thanks for Mary Ann Halpin's insight showing us a place to start—creation.

This book is dedicated to my mother and father, Ginny and Joe Esterle, with love and gratitude,

who adopted me from birth and included me in their family as their "miracle baby"

with unconditional love and spirituality and taught me to see the true beauty of life,

and to my husband, Joe Croyle, who loves me with all his heart, holds me, comforts me, cooks for me,

and supports me in being the creative, powerful goddess that I am today—I love you madly.

Acknowledgments

PHOTO ASSISTANTS Anna Flavin—for her Irish humor, strength, and techno head • Carolyn Escaip—for her sensitivity, intuition, and logic • ADDITIONAL PHOTO ASSISTANTS Leslie Campbell • Bri Esterle • Jonathan Reinstein • Jason Van Fleet • SPECIAL THANKS Theo Sjolberg—hair and makeup and moral support • MAKEUP AND HAIR Lorraine Altamura • Aimee Burke • Cyndra Dunn • Caroline Keenan • Sandy Williams • RESEARCH Amy Esterle • TECHNICAL SUPPORT A&I Color Lab, Balcar, Calumet, ELS, Hasselblad • Isgo Lepijian Black & White Photo Lab • Nikon, K&H Photo Lab, PRS

SPECIAL THANKS FOR SUPPORT Beth Broderick for the black bra, Beau Deshotel for draping, Marcelene Dyer for her personal insight, Dr. Wayne Dyer for true inspiration, everyone at EC2 Costumes for their magnificent support of this project and their creative costuming, Claudia English for the butterfly wings, Linda Gray for the teepee, Dennis Holahan for superb legal support, Linnea Lenkus for photo input, Dan Keough for the swing and the crescent moon, Cathy McAuley for the mermaid's bra and the bird's nest, Linda from Behind the Scenes for her artistry, Brett Hadley for your support on the golf course, Michael McCreary for being there, John Swain and Marsha Mercant for their San Francisco pad, Anna Gabriel for being there at the very beginning, Laurie Levin for consulting, Rebecca Czuleger for sharing her professional insight, Cassandra Peterson for spreading the rumor that I was doing a pregnancy book, Demi Moore for being a true pregnant goddess, Rodney Kageyama for the beautiful kimonos, the Japan American Cultural Center for their exquisite gardens, Dr. Gary Schummer for keeping me out of my own way, Jim and Roxie Esterle for their love and generosity, Laura Robinson and Marc Ettlinger, and Gosia and Marek Probosz for allowing me to witness and share in the birth of their babies, General Publishing Group for their guidance and faith in me, and to all the pregnant goddesses in this book for sharing so much of themselves.

Thank you with all my heart.

To:

From:

Date:

Love gives life to us all…

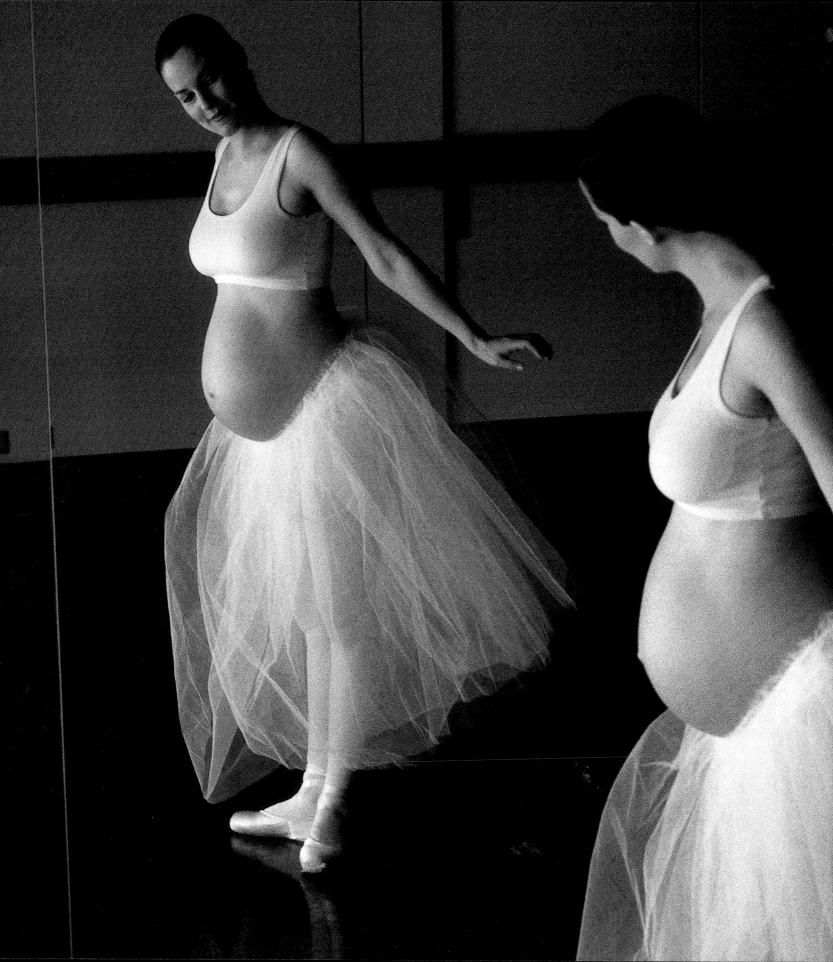

Diamelen Partridge

After the baby starts moving in the womb, there's this cozy, comforting, exciting feeling that inhabits you constantly.

It's fun knowing there's a person inside you who goes everywhere you go, hears your thoughts, does what you do,

and eats what you eat. It's kind of like a nine-month-long slumber party

that is capped off with a surprise party (if you don't peek).

My definition of myself is less about "me."

The focus has shifted to this wonderful little person who is a part of me,

and it's actually more liberating than limiting. Instead of losing sight of yourself,

you feel more at ease with the depth of person you discover.

~

Malakai Cody

Born March 24, 1996

Cassandra Peterson

Like many professional couples, my husband and I had postponed having a child because of our busy career schedules.

We finally made the leap and began "trying." Getting pregnant proved to be no problem, but after only three months, the pregnancy

ended in miscarriage. Over the next two years, there was a second and third miscarriage, after which we embarked on a series of

costly and painful medical interventions that all proved fruitless. We suffered a fourth, then fifth, and then sixth miscarriage.

Emotionally and physically devastated, I decided I just couldn't try anymore. It took a great deal of soul-searching

before I finally accepted the heart-wrenching fact that having a child of our own was just not meant to be. No sooner had I come to

grips with a childless future then I discovered I was pregnant for the seventh time. I became deeply depressed.

When my obstetrician insisted I come in for an ultrasound and a hormone-level test, I reluctantly agreed.

All I remember that day is my doctor announcing, "I think this one's a keeper!" My "lucky seventh" pregnancy

was one of the most overwhelmingly happy and thrilling times of my life. I experienced a sense of well-being and centeredness that

I'd never felt before. After 15 years of marriage, at the age of 43, I delivered a beautiful, healthy baby girl.

And she is all the more precious knowing what we went through to become a family.

~

Sadie Leigh

Born October 12, 1994

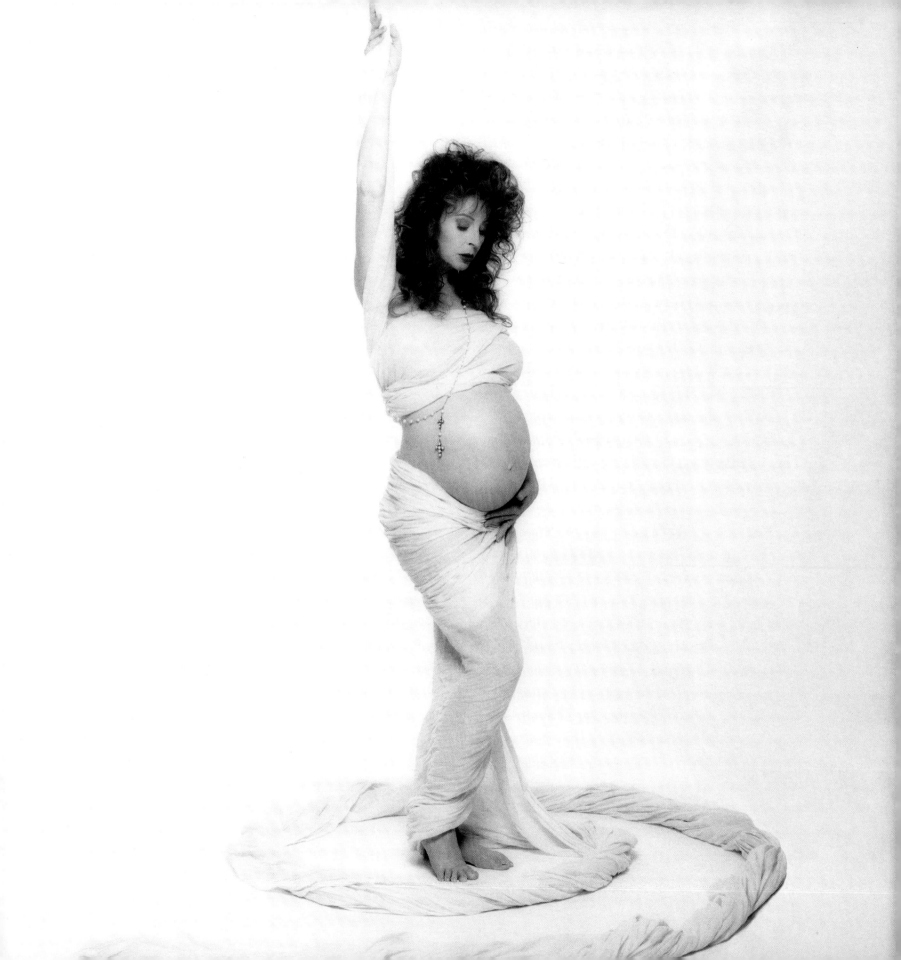

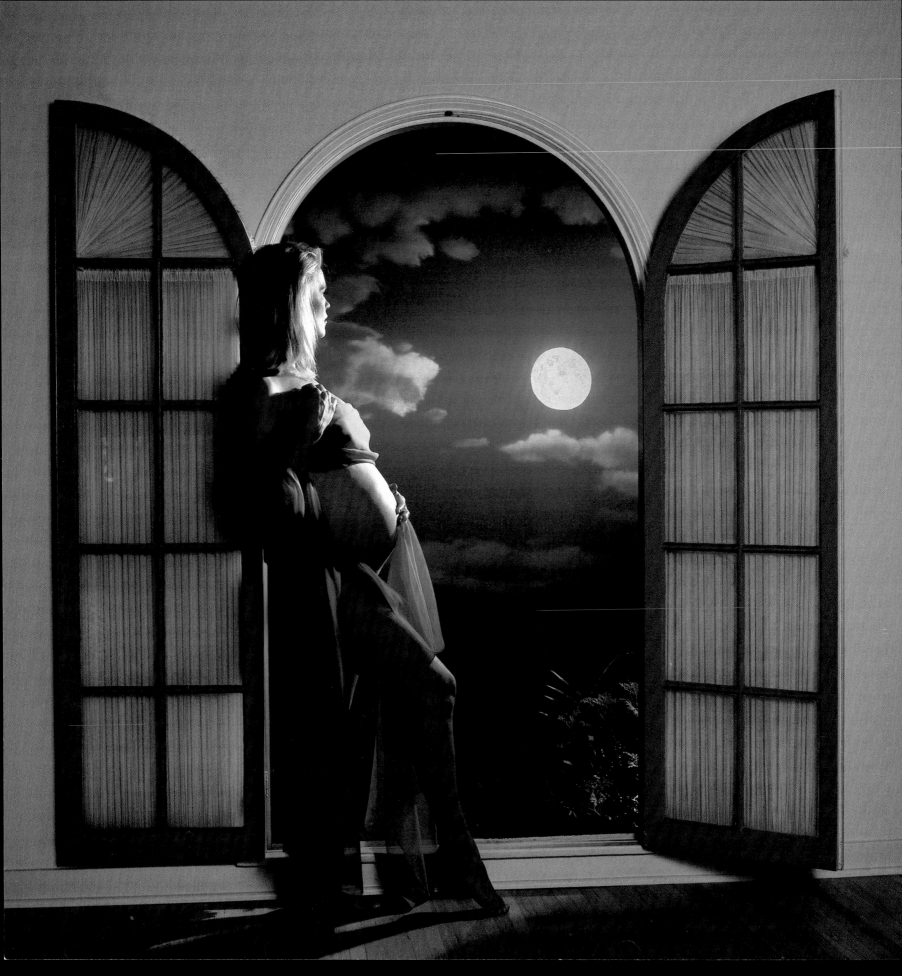

Julie Fowler

Once in a blue moon we have the opportunity to experience a miracle.

Two incredibly profound events happened in my life, one of great sorrow and one of great joy.

First, my father passed away as I held him in my arms. I was looking straight into his blue eyes as his light left his body.

Second, my daughter was born exactly 40 weeks to the day of my father's death.

When my father was passing, our eyes locked. I felt him transfer the last of his power into my soul.

At that moment, I felt honored that he had chosen me. When, two weeks later, my doctor told me I was pregnant, I knew that my

father's death would empower the life of my daughter. I have experienced the purest meaning of the "Circle of Life."

The blue moon is as rare as my experience of death, sorrow, life, and joy. In death, I was given a beautiful daughter, Francesca.

In life, I was given the loving memory of my father, Willard. I am truly blessed.

~

Francesca

Born May 31, 1997

Kay Bowling

When I found out I was pregnant, I dreamed your spirit came to me and told me how important it was for you to be here. Despite not feeling ready to raise a child, as the days passed and the dreams intensified, I realized how much I wanted to bring you and your glorious spirit to life. One night I had a very special dream: I was holding you in my arms, and we were talking to each other with our hearts. The next morning, I felt your spirit near, and the word "hope" came to me.

Still, for the next seven months, I struggled with the decision whether to keep you and raise you alone while finishing up a rigorous year and a half of photography school. My love for you led me to believe it would be best for you to be raised by a loving family, one that could give you more than I could at this time in my life: not just the financial support but, most important, the family life I'd had growing up and that I wanted you to have.

You arrived right on time: at 12:19 am on April 15, 1997, your due date. It was the most beautiful, natural childbirth. I loved every minute of it. But I had complications delivering the placenta, as my uterus held on to it. I lost a lot of blood and was near death. After five days in the hospital, the doctors telling me that my chance of having children in the future was risky, I rethought my decision to place you with an adoptive family.

You are sitting on my lap as I write this. Tears come to my eyes because I can't imagine not having you here with me. Every day, I thank the universe for giving me a chance to reconsider. I believe my difficulty delivering the placenta was a sign that I wasn't prepared to let go. I don't need to be rich or have someone by my side in order to raise you—all I need is the hope and love you give me, reciprocated. It is our destiny to be together. You are an angel.

~

Hayley McGinnes
Born April 15, 1997

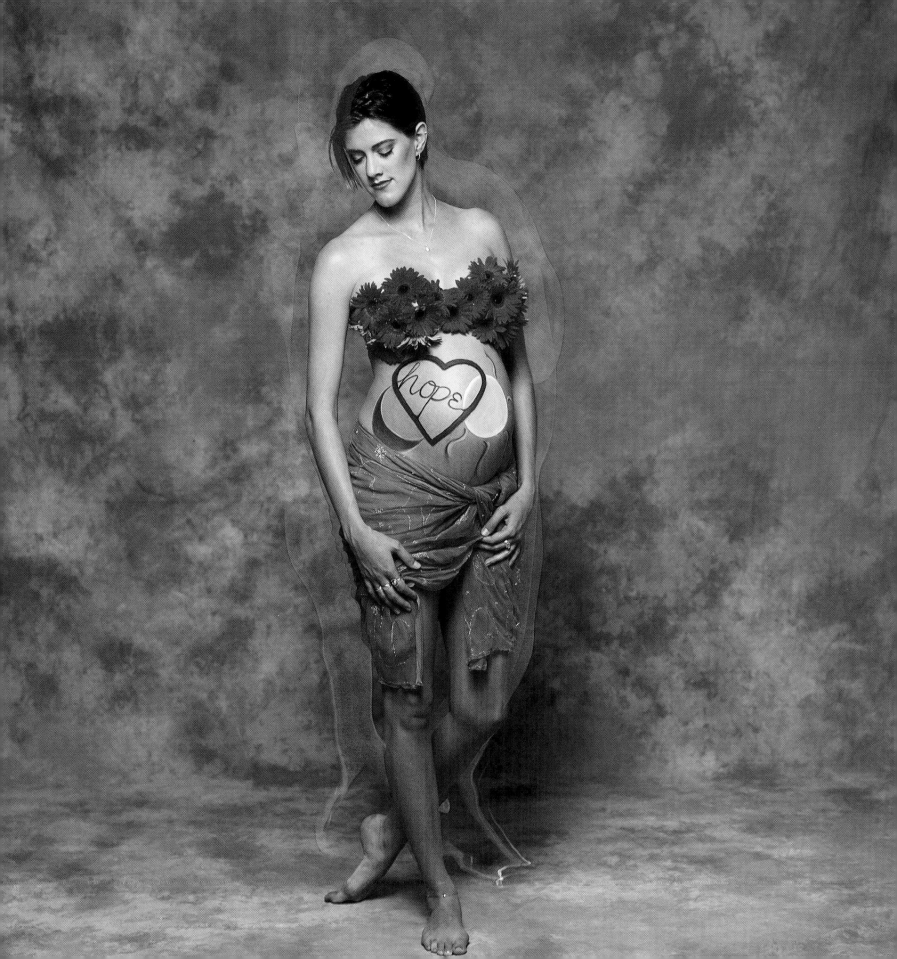

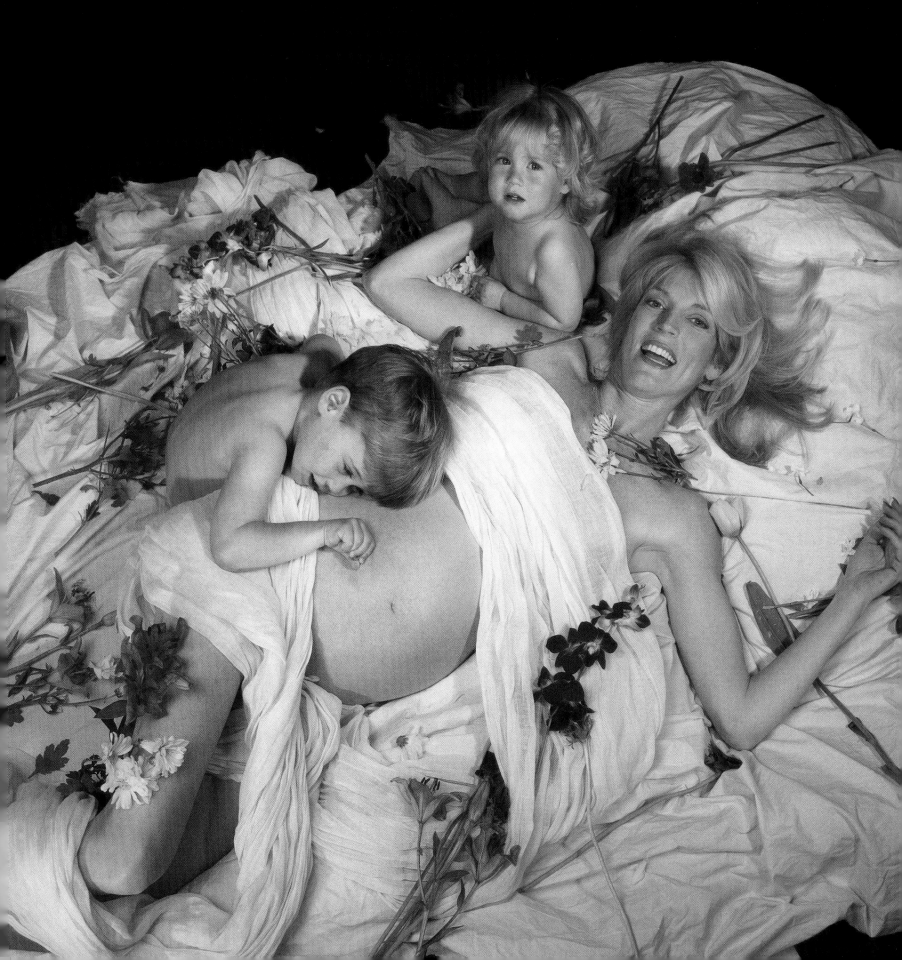

Kerrie Sanders

Now I know where the expression "three's a charm" comes from.

From the beginning, this unexpected pregnancy—except for shock—has been nothing but pleasure.
Before I knew I was pregnant, I remember thinking, "Gee! I feel great today, and, except for that bout with food poisoning,
nothing could bring me down."

Throughout this entire pregnancy, not only have I felt wonderful, but I have had an unbelievable ability to recognize life's
small pleasures—even through the chaos of caring for two young children. One thing that has stood out during these 10 months—
yes, that's right, 10!!—has been my attraction to flowers. The beauty, the scent, the delicacy—I can't seem to smell or see enough
fresh flowers in my day. No matter what may be happening on any particular day,
the presence of flowers can always make me smile.

As I write this, knowing I could go into labor at any moment, my feelings are bittersweet.
I am excited and looking forward to a new bundle of love in our home, and yet saddened by the fact that I will never experience
pregnancy again. I understand that pregnancy is not always a wonderful experience for every woman, but for those of us who enjoy
being "with child," there is no other sensation that will ever come close to the magnificent feeling of pregnancy.

~

Duncan Ezra

Born March 6, 1997

Kathleen Campbell

I've always been a character actress. Being pregnant makes me feel like a beautiful blonde.

Now I know what my body is for.

I am a vessel, a gorgeous, overstuffed, Louis Vuitton suitcase of our love.

My husband is part of this, but I am the lucky one.

I never thought I'd be enjoying this transformation as much as I am.

I'm certain there will be laughter ahead. I know there will be love.

I'm overjoyed to take myself seriously right now. I am substantial.

~

Richard Macadam

Born September 1, 1995

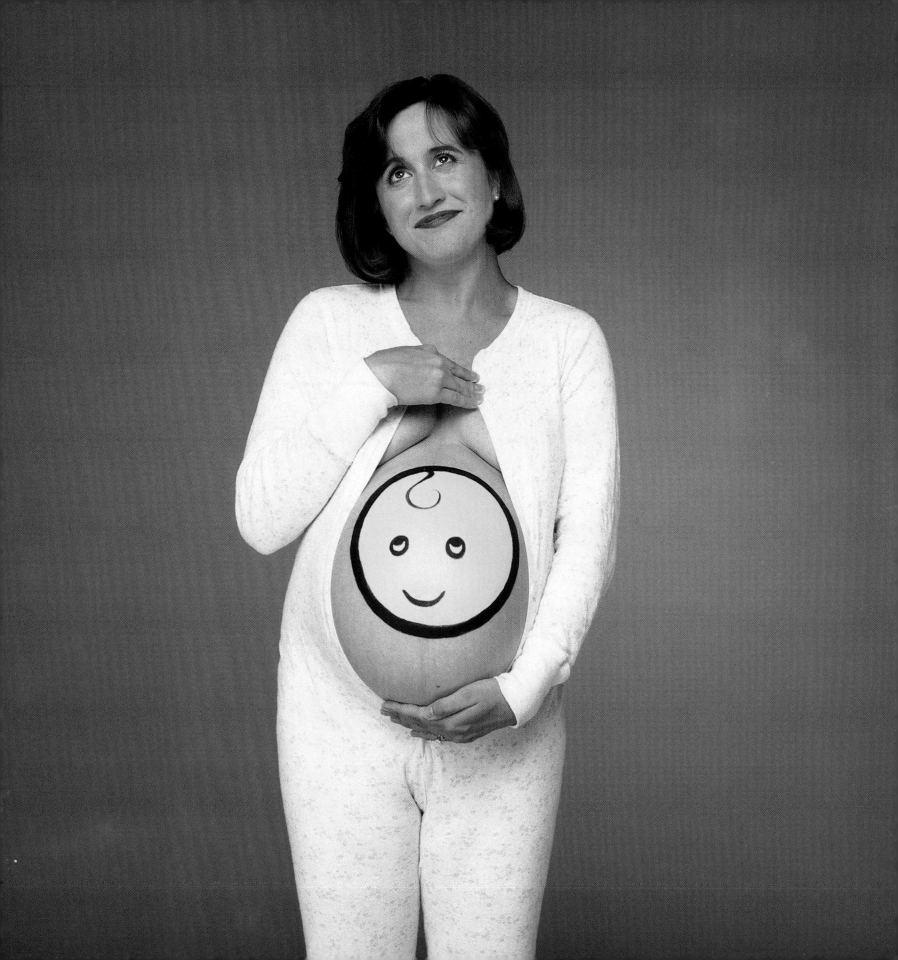

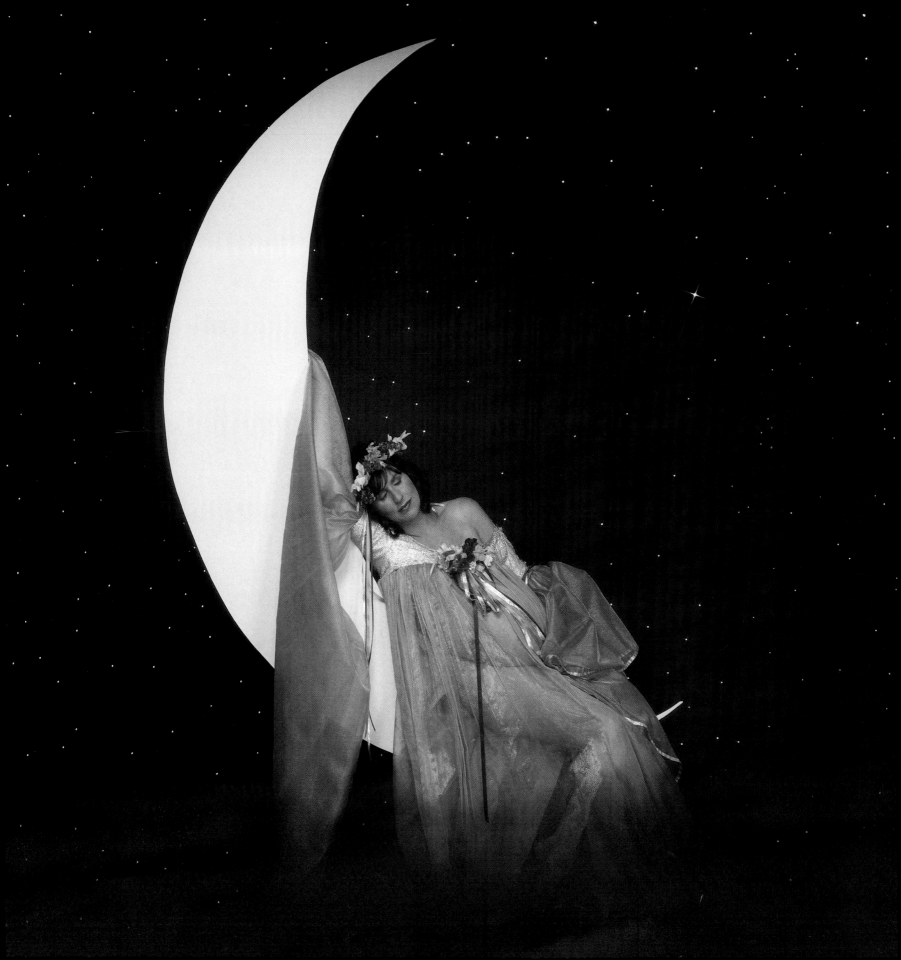

Amy Somers

Hey diddle diddle.

Not one but two in my middle.

And how do you think I feel?

I feel higher than high.

Blissful, in tune.

This mom's sittin' on the moon.

~

Sasha Rose

Noah Samuel

Born May 29, 1997

Sharon Hays

Precious baby girl

wrapped in this cocoon of love,

when will you emerge

and unfold your graceful presence?

Will you be fair and soft like the morning light,

dark and dreamy as a stormy sea,

or golden amber like a sun-kissed peach?

Your family awaits you eagerly:

your place set at the table,

two loving brothers ready to embrace you

and show you to the world,

Daddy strong and kind to hold you and kiss your worries away,

Mommy filled with nervous anticipation...can I do this again?

It has been eight years since the last angel landed in our home.

Will this be different? I thought we were past this time of babies

and sleepless nights. What special challenges will you present us?

A little girl in a house of boys.

I know the challenge well: I was once that little girl myself,

cradling dolls in the midst of an army.

I welcome you with open arms.

~

Piper Samantha Lynn

Born May 11, 1997

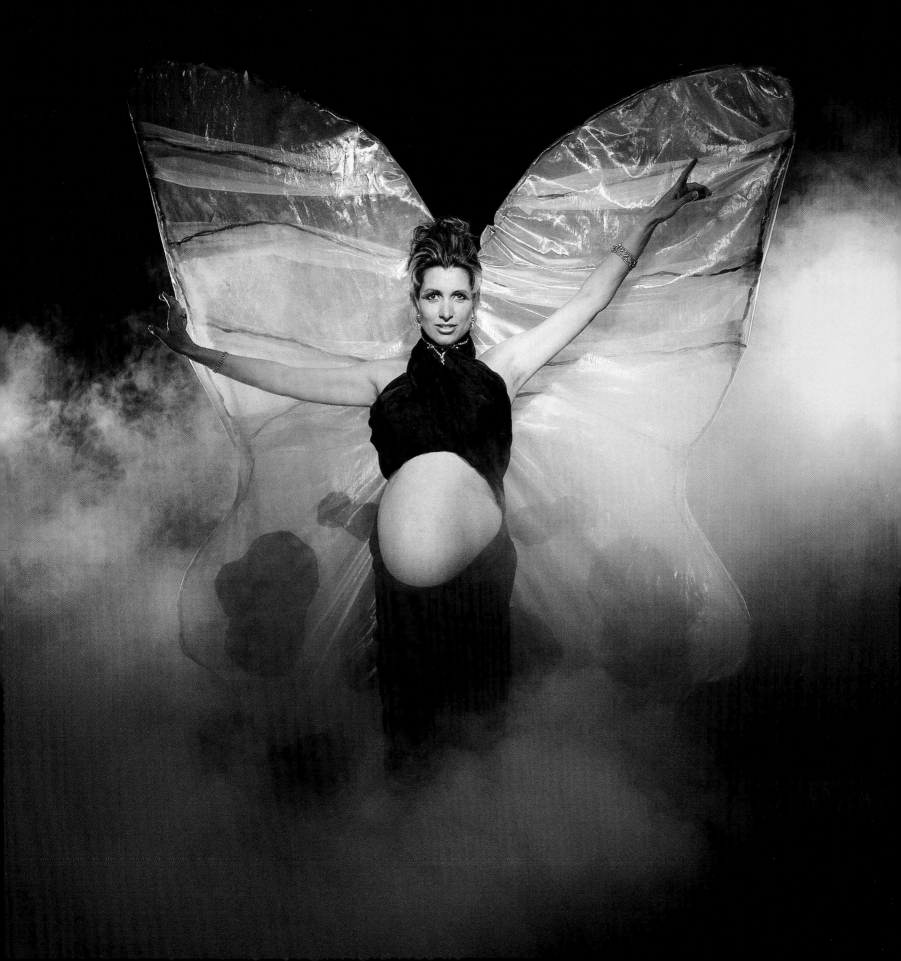

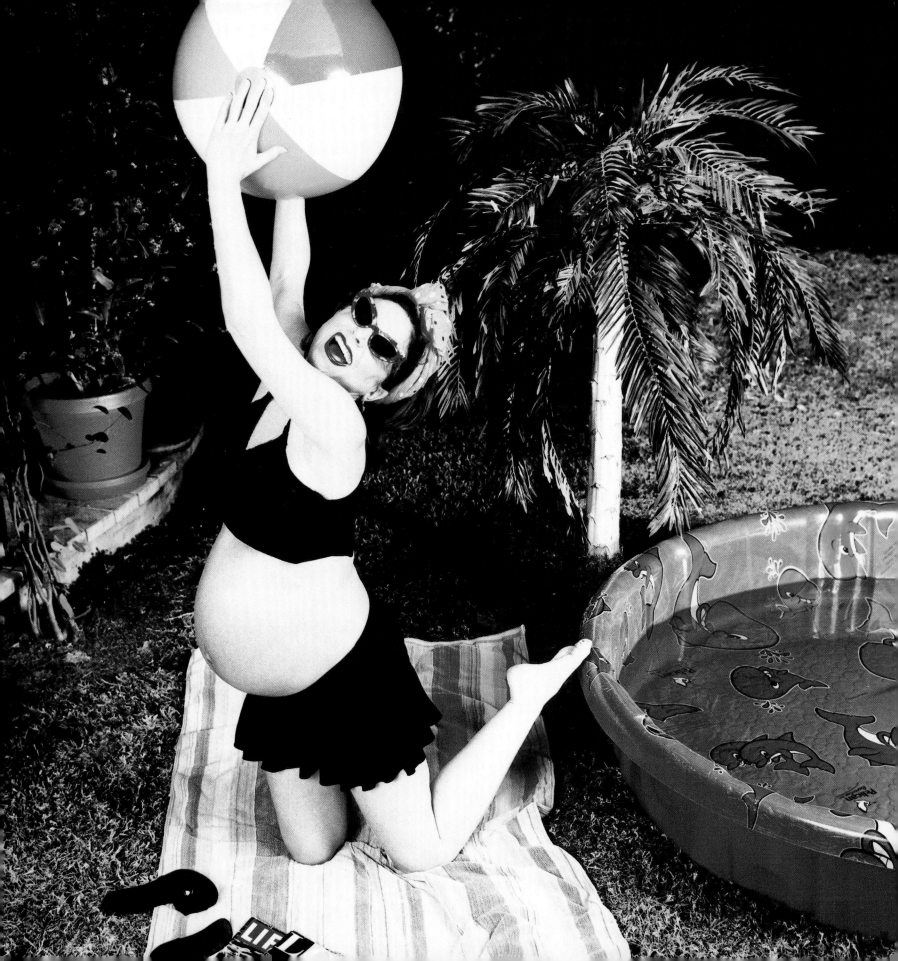

Dinah Manoff

The first trimester. I am so tired. I feel like I have the jet lag that would follow flying around the world three times.
"No, I can't come over for dinner; I can't even lift my coffee cup." I sound so cheery and alert on my answering-machine message,
it gives people the wrong idea. They don't know me now, the real me, the me that lies under the covers, on top of the Saltine crumbs.
The only things that make me feel better are looking at the ultrasound pictures,
at the speck who is my beloved child-to-be…and ginger ale.

The second trimester. Wow, I am so busy. Busy buying baby things and fixing up his room. Oh yes, it is a he…the results came in.
A son! I sing it all day long. I am loving my body, my changing self, my beautiful belly. I eat without a care, feeding my boy
within, plumping us up. I love being pregnant. I take myself to infant-care class, breast-feeding class, prenatal Yoga class, where we
all ooh and ahh over one another's bodies, comparing symptoms, exchanging stories and due dates and doctors and procedures. I
show off my ultrasound pictures. My little speck now has hands and feet and penis and a name. Dashiell.
I write it everywhere, like a lovesick schoolgirl. Dashiell.

The third trimester. Waiting. I am overdue. I am losing my mind trying to fill the time until Dashiell is born. There is nothing
more to prepare or shop for. Lamaze is over. I could waddle my way over to Yoga, but I can't stand everyone saying,
"Are you still here?" My husband and my mother smile lovingly and cut a wide berth around me. I hate them, but I don't let them
know because I need them to bring me things and rub my feet, and besides, I have a hunch that I'm not in my right mind.

One week after birth. My miracle is here. My child. I have always wanted to say that: "my child." The labor was horrendous. I
ended up with a C-section—the one thing I didn't take a class for. My breasts are engorged and my nipples feel like sandpaper's
been rubbed on them, but none of this matters when I hold my child, when I smell him. He lies between us on the bed, and I look over
at my husband, who is looking at our son with such complete adoration. We are blissfully, stupidly happy.
This is my family. Love is bouncing off the walls.

~

Dashiell

Born March 26, 1997

Miriam Clarke

During my pregnancy with Colin, whenever my son Ian would have his bath,

he would say, "Come on in, Mom, it will help you to relax." Pretty wise for a three and a half year old. It helped a lot.

Later, Colin confided that it was great fun watching the water rise almost to the point of spilling over the tub.

(I used that moment to teach him about water displacement.)

This photograph was shot four days before delivery. Once again, the tub proved to be surprisingly relaxing.

I lay there playing the flute excerpt from Felix Mendelssohn-Bartholdy's "Midsummer Night's Dream Overture."

The flutist is allowed only three specific breaths in this musical piece, which can be extremely challenging.

I thought that certainly with this huge belly I would never make it, but somehow it all came easily.

The very next day, I recorded a commercial with my husband, Jon.

I had to hold the last note for what seemed like an eternity.

The only thing that made it possible was picturing myself in beautiful Topanga Canyon,

floating in a bubble bath, my son Ian conducting.

~

Colin Thomas

Born February 4, 1997

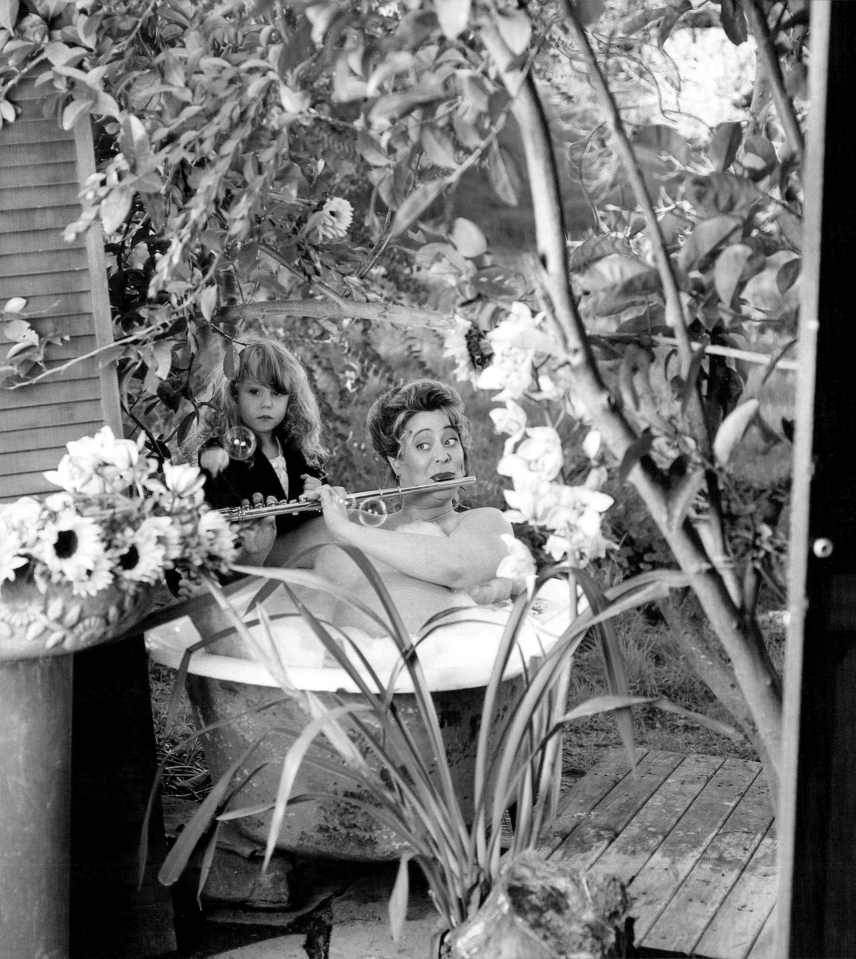

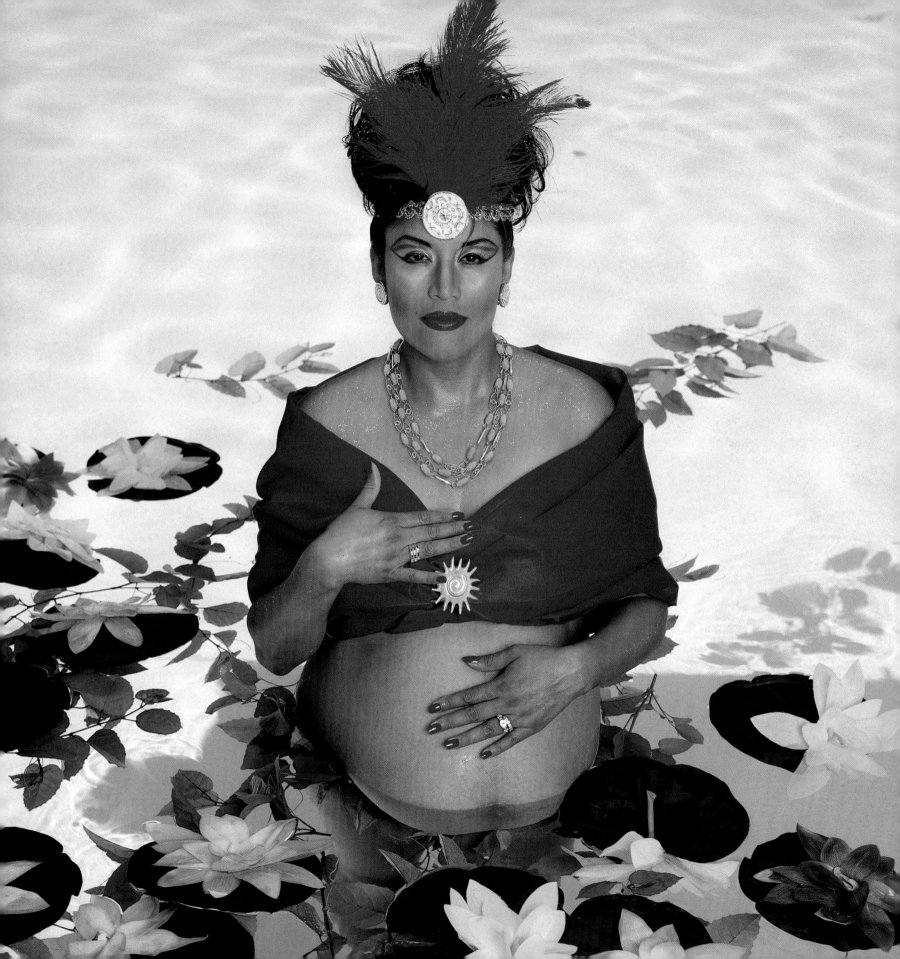

Claudia English

One of the most beautiful things a woman can experience is pregnancy. Although both of my pregnancies were difficult

and had me bedridden for a couple of months, memories of my daughter's and son's first kicks in the womb

dispel those discomforting moments.

Having experienced life exclusively with my daughter, Briana, for 14 months,

the thought of loving another child with the same intensity seemed impossible. As my belly grew bigger, so did my fears.

But such concerns left me when I held my two children close and knew there was plenty of love for both of them.

As time goes by, the challenges remain. I love Briana and Ryan with the same intensity as I did

the first time I held them in my arms. Parenting is difficult at times,

but I would not trade it for all the gold of the Incas.

~

Ryan Christopher

Born July 26, 1996

Laura Robinson Ettlinger

The moment I woke up, I knew this was the day.

It wasn't long before my contractions started, and by mid-morning, they were five minutes apart.

So I closed my eyes. "Julia, can you wait just a little longer? There's still one thing I need to do."

Almost immediately the pains subsided.

Mary Ann arrived in the early afternoon, and by sundown, we had what we wanted.

Julia had been very patient. Within 10 minutes, the contractions, which had been so intense that morning, resumed.

It was time to go inside and light the candles. Then, with the support of my husband and son,

my closest friends, and one fabulous photographer, my daughter was born underwater,

placed into my arms, and yawned...two hours after this picture was taken.

~

Julia Robinson

Born March 11, 1997

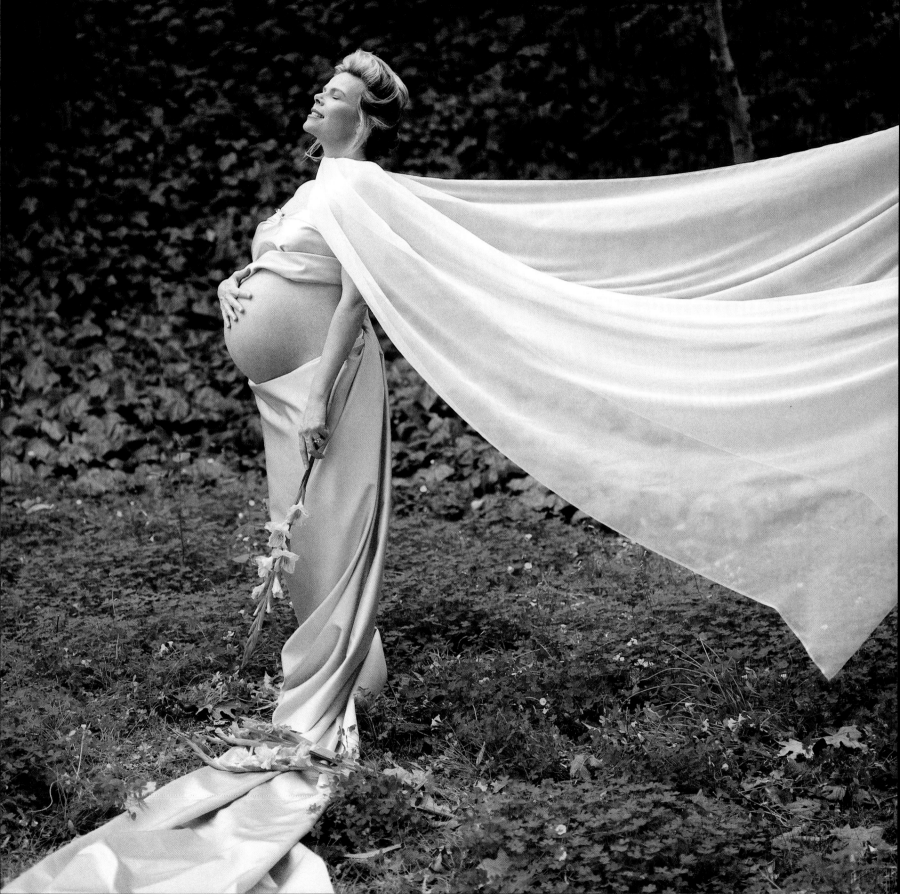

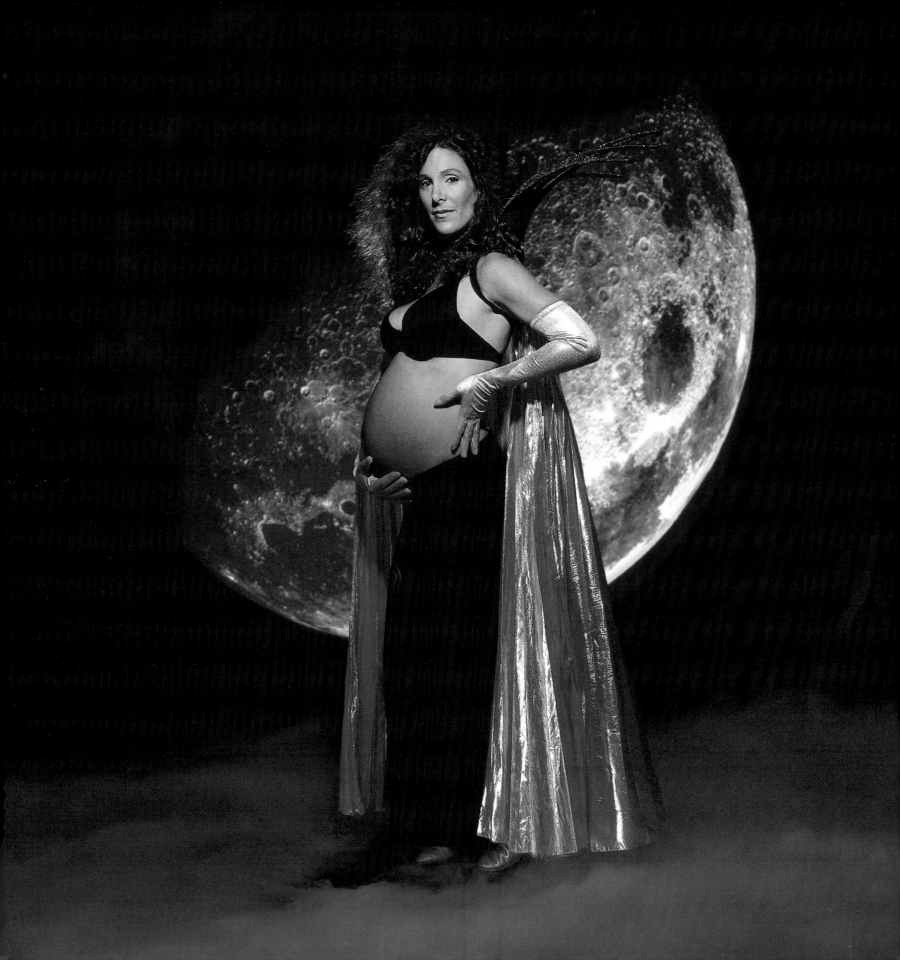

Stefanie Henning

Twinkle, twinkle, little Jessie,

How I wonder who you'll be.

What dreams you'll follow,

What loves you'll sow,

What yearnings will drive you to drink

From life's rich cup,

Fearless, unrelenting, savoring every drop.

I wonder, too, who I'll be,

In this adventure which now beckons you

With a carnival barker's zeal.

Friend and adversary,

Mentor and pupil,

Giver of praise and maker of rules.

One thing is certain, though, from the moment you arrive,

Until the earth turns to dust,

I will remain the one thing you made me:

Your mother.

~

Jessica Leigh

Born June 17, 1997

Sofie Howard

Sometimes we forget about the humor in pregnancy.

We forget about the rampant eating, horrid gas, and ridiculous outfits.

This is my second baby, and with this pregnancy, I was determined to focus on the "light" side (if there can be one)

and have some fun. Fighting with a stray dog over a turkey leg is my idea of an activity

that is especially amusing at nine months pregnant.

However, through all this hilarity, I simply cannot forget the fact that a beautiful loving baby will surprise me in a few weeks.

An actual person my husband and I can cherish for the rest of our lives.

~

Hayden Barron

Born June 13, 1997

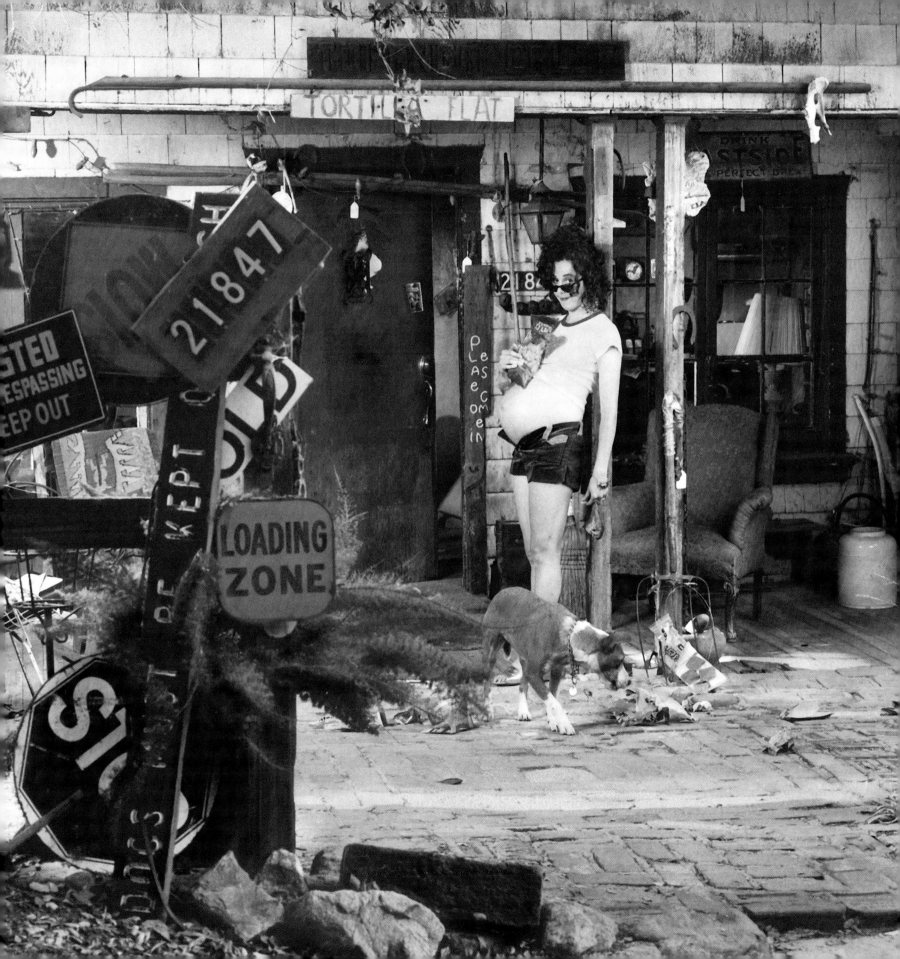

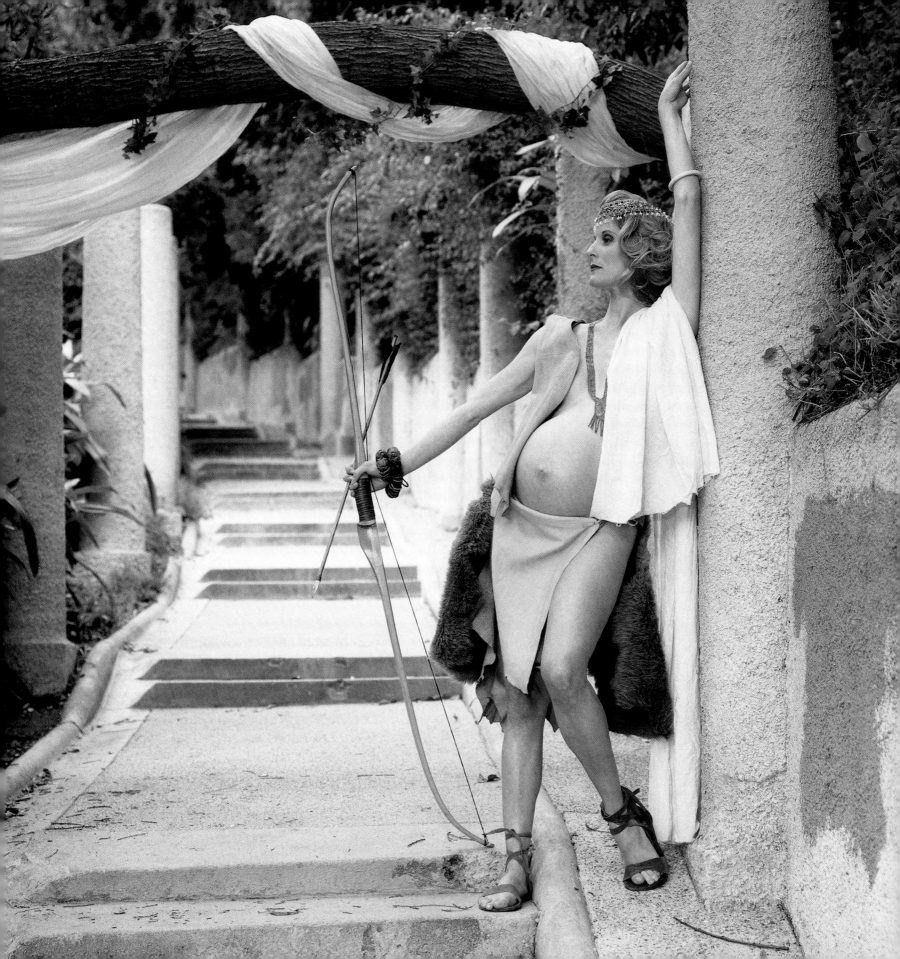

Melissa McFarlane Hunt

The image of myself as "god" or "goddess" seemed especially real in the carrying and birthing of my child.

For me, the act of pregnancy and delivery was spiritually transformative. It united me, an individual, with a larger community—

the community of humanity and, therefore, the world. Parenting is an extraordinary act of participation with life itself.

To say which goddess specifically directed and continues to direct me most seems difficult. Is it Aphrodite, Goddess of Love?

Hestia, Goddess of the Hearth? Artemis, Goddess of the Hunt? I've felt each presence guiding me.

At times, an overwhelming love, greater than my own individual capacity for loving, floods over me.

People tell me I am radiantly beautiful. Aphrodite winks. And yes, "home" has a new meaning. Creating comfort and beauty

are holy priorities now. Hestia smiles upon me. But there is more. Each day, I face the world, fierce with my mission:

to provide and protect. Each new opportunity for me or my business is more carefully studied. Will it encourage growth? Does it

represent integrity—for surely that is something I must model for my child, this new member of the tribe?

The goddess Artemis weighs in.

It appears that motherhood awakens the spirit of all these powerful goddesses. As I sit in the rocker, deep within my home

(my cave, my castle), nursing my man-pup barely four days old, I have ready by my side two things: a rapier to defend against

threats to my son (injustice, intolerance, greed, hatred, fear born of lack of love) and a feather to grace him with comforts

(love, beauty, laughter, abiding confidence deep within his soul). I will not hesitate to use either.

Would you? Never! Humanity is community.

~

Tulley Patrick

Born April 18, 1997

Pia Reyes

Am I a flower about to bloom?

Maybe a caterpillar before its splendor

Or a birdling cheeping for worms?

Everything...unfolding like morning dew.

I can hear soothing raindrops

And feel sweet sunshine seep through

My virgin bones.

"I," who am "I"?

I feel myself embark upon this journey.

It feels safe, warm, happy, and new.

Oh, giver of life...who are you?

I feel you in me, and me in you,

And not just one but two. I am but the two of you?

Oh, givers of life...are we to meet soon?

I'm coming...Yes, I'm coming

Because each day feels like

My birthday.

~

Zeus Abraham

Born April 4, 1997

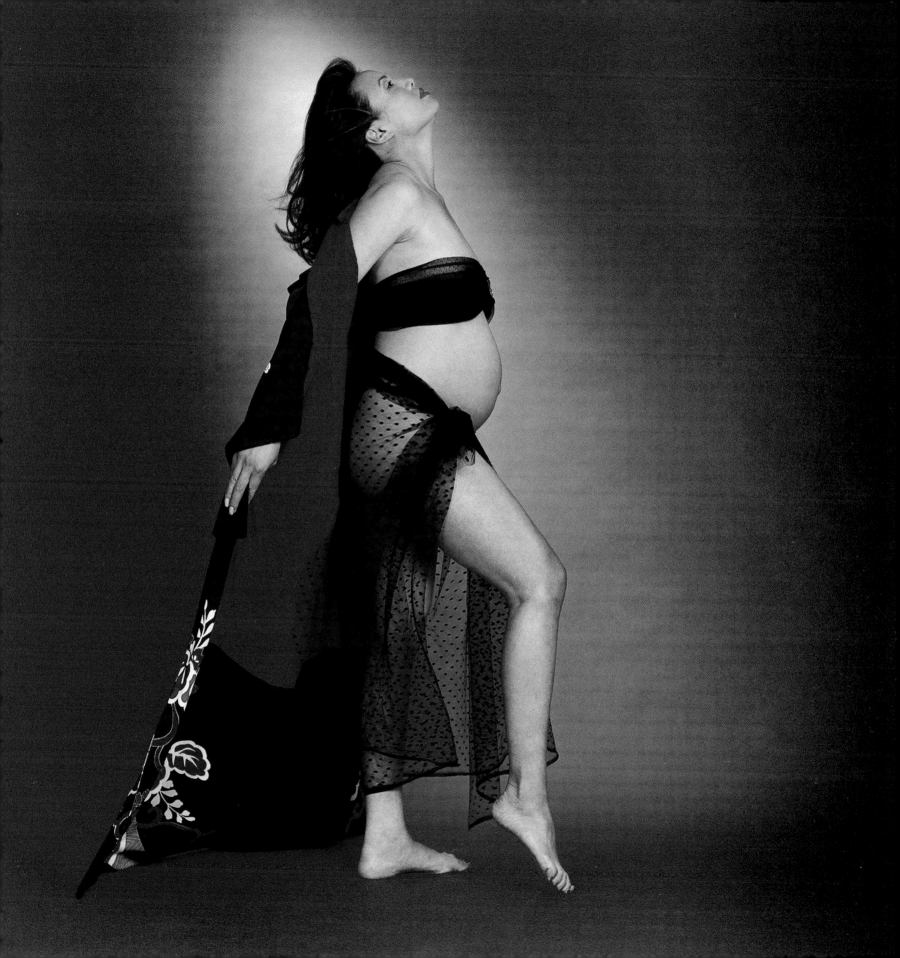

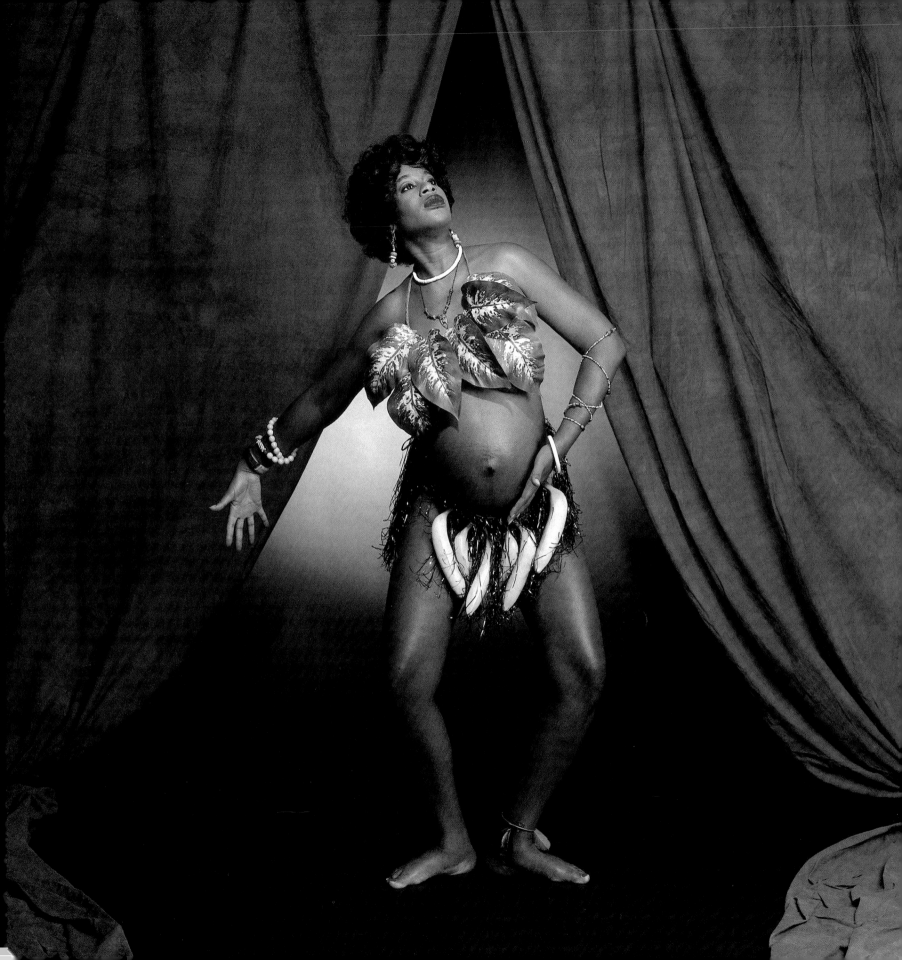

Francine Julius

When I first found out I was pregnant, I was betrayed by advice regarding my physical condition

and its effect on me. I was warned of feeling fat and unattractive and oversensitive.

But you know what? Each month, as this little person grew inside, I kept on feeling sexy.

I looked good and danced at parties and could laugh at myself. For instance: as I was standing on a set for some TV show,

my belly blocked an actor sitting on a sofa. It was hilarious—which leads me to my choice of Josephine Baker's banana dance.

That was a very seductive, entertaining, yet taboo dance back in those days. Talk about grabbing attention!

I did get wonderful, positive attention from mothers-to-be and especially from fathers-to-be who wished their wives and girlfriends

had my attitude. I'm bringing a new life to this planet! It is a time for joy, not for dwelling on aches and pains.

And talk about proud—my baby's father and I have been grinning ever since.

Her grandmother, who witnessed the birth, has been grinning, too.

~

Niyah Kamilah

Born September 26, 1996

Marki Costello

I was married for the second time in May of 1996. That June, on vacation at Martha's Vineyard, I got pregnant—

one month after my wedding. It was all happening so fast, I was excited and afraid…excited because I knew my life

was going to change…afraid because I knew my body and how people viewed me and, most important,

how I viewed myself were all going to change.

Before I was pregnant, I would see pregnant women and a little devil voice inside me would say,

"How does a body stretch like that and then go back to being normal?" Of course, I saw women who gained the weight

and then lost it, but my devil voice convinced me I wouldn't be one of the lucky ones. I vowed when I found out I was pregnant

that I would never look at myself in the mirror, my husband would never see me so stretched,

and I would not let anyone photograph me for nine months.

Well, being one month away from giving birth and about to have my picture taken for a book,

I have never felt so powerful and so glamorous. Carrying life is one of the most beautiful things I have ever done.

And, by the way, looking in the mirror and seeing life stare back at me is one of my favorite pastimes.

~

Lucas Henry

Born April 2, 1997

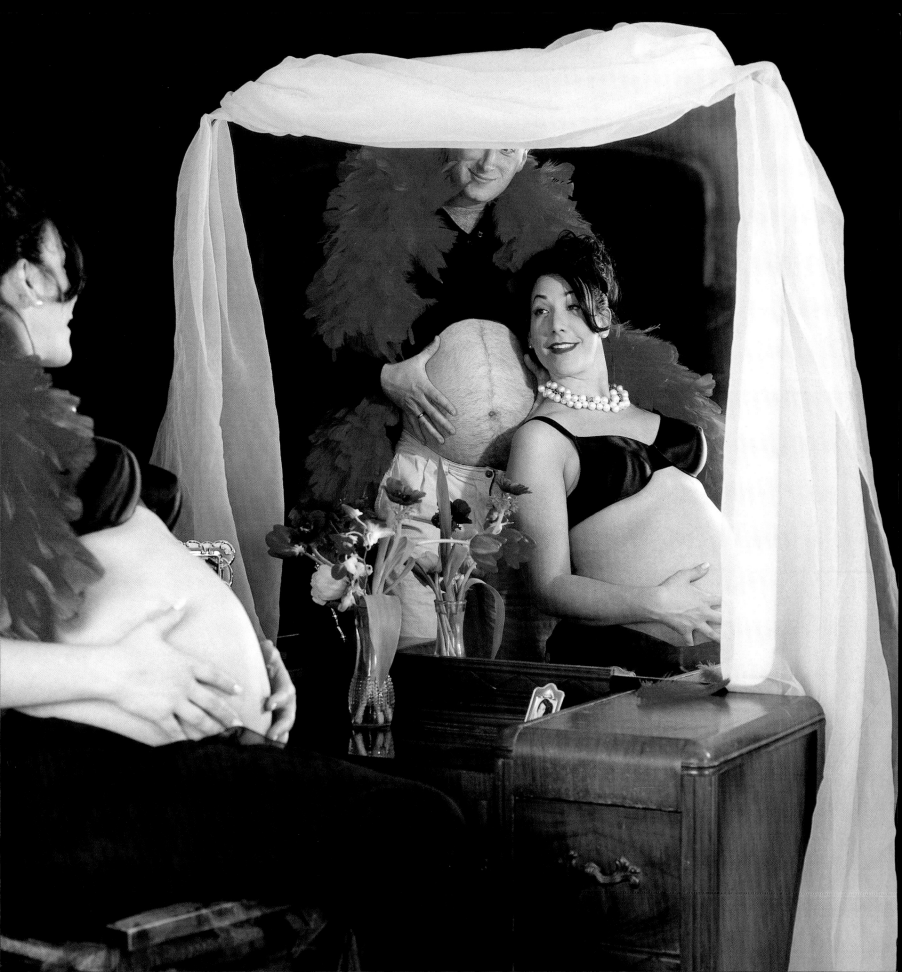

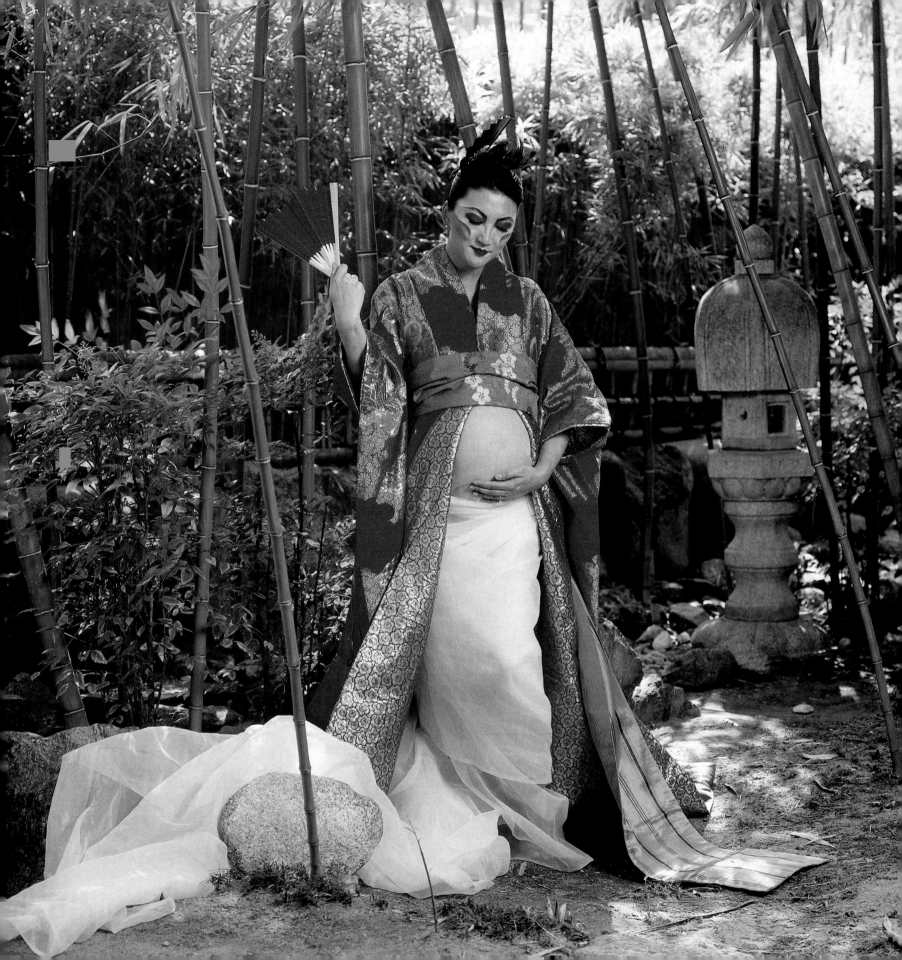

Stella Jeong

As I stand in this grove of bamboo trees, I reflect on my experience of being pregnant.

My pregnancy has ignited all the elements of my inner self, mind, body, and soul. It has allowed me to channel energies that had

centered on my career to areas deep within myself. I have found my equilibrium and, along the way,

have discovered the intricate complexities of body and soul.

In many ways, I feel that the child within me has been my guide throughout the past nine months.

His presence within has nurtured and expanded the positive energy of my consciousness. The rhythm of his movements

is a constant reminder that there is so much more to myself I have yet to explore and discover.

I know that he is preparing me for childbirth, the right of passage which will lead me to the difficult job of motherhood,

requiring strength, sacrifice, tolerance, patience, and above all, unconditional love.

I owe a great deal to him, because he has guided me to a place within myself that is serene and peaceful, like the bamboo forest.

Mentally, I am focused. Physically, I am invigorated. Emotionally, I am harmonized. Together, we are strong.

~

Nicholas David

Born May 4, 1997

Cathy McAuley

There's no need to guess,
we found out today,
E.P.T. test said, yes.

Hip, hip, hooray!
It was Kenny and me,
now Remi makes three.

You wanna know fear?
It's to look in the mirror
and actually ask yourself,
whose is that rear?

My ankles aren't great.
This is more than water weight.

From beginning to end,
you'll get cravings, they say.
No, no, not me, my friend,
I just eat all day.

Are you gonna eat that?
Then pass me your steak fat.

Oh, when will she come?
I know it's near.
Never mind…she's here.

~

Remington
Born April 14, 1997

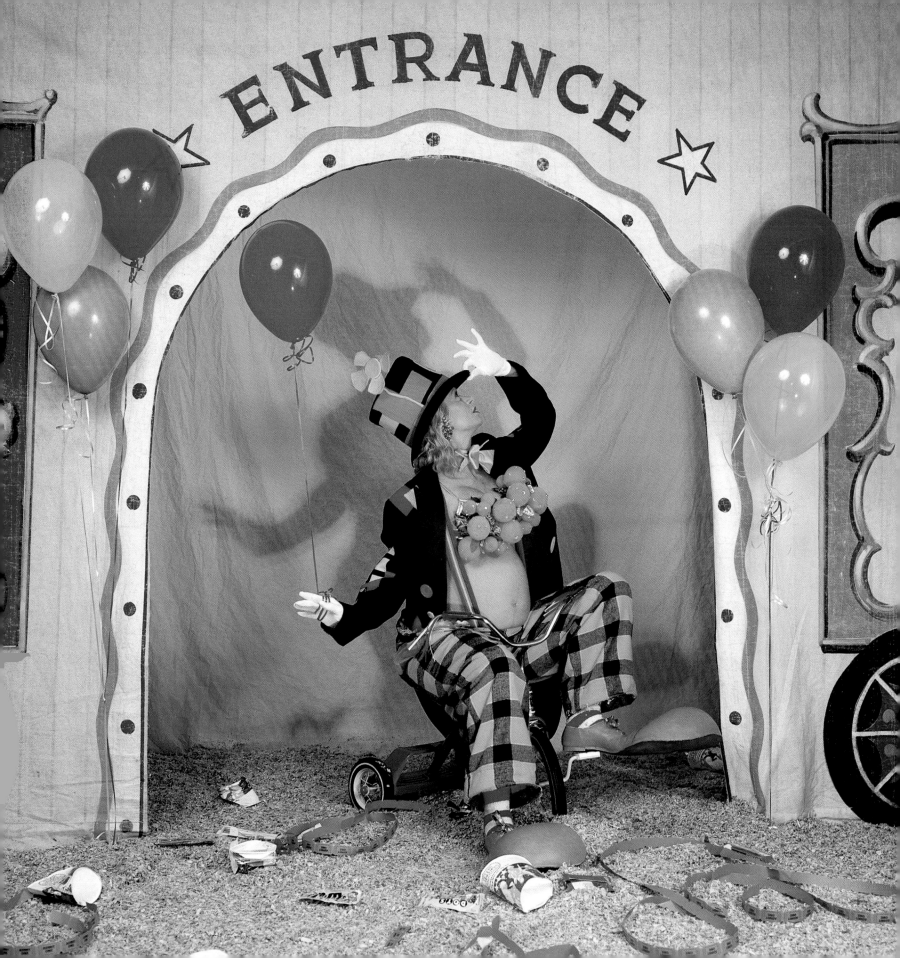

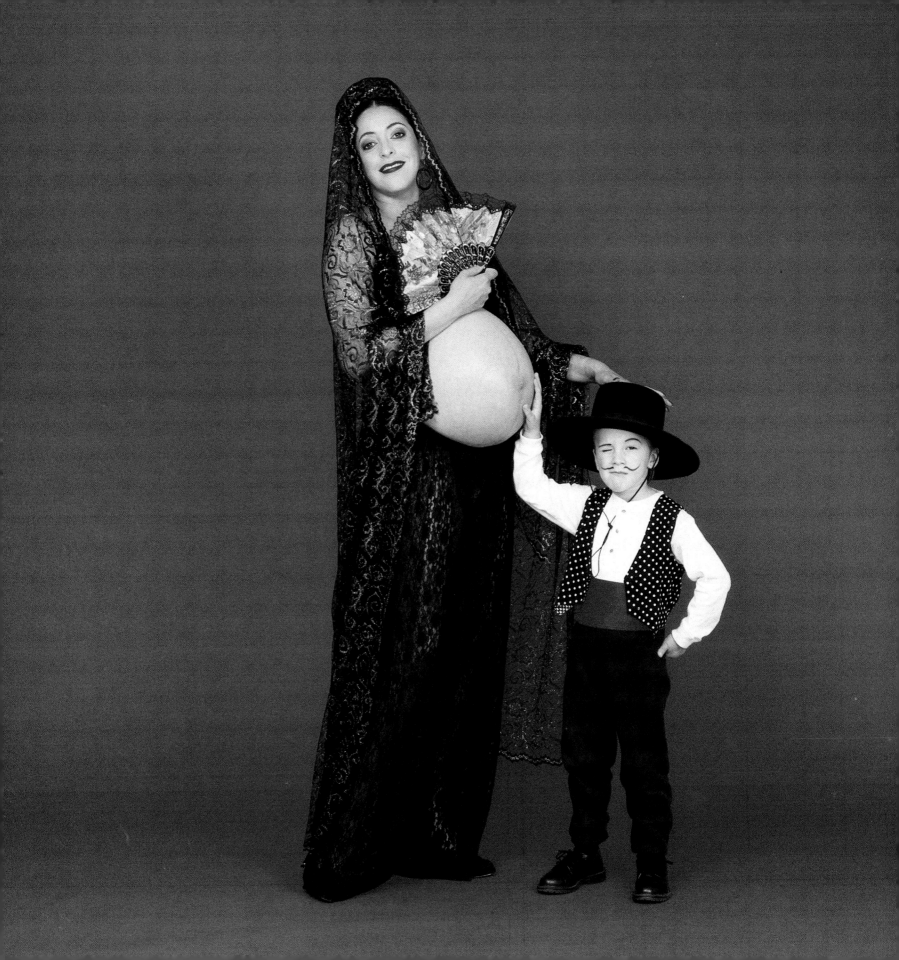

Norma Maldonado Buha

Being pregnant brings me closer to my roots. I want to go back to my heritage.

In Puerto Rico, we call Spain La madre patria, *the Mother Land. How appropriate,*

because I feel such a strong connection to the passion and love of life the Spaniards have.

During my first pregnancy with my son Jovan, I felt a strong creative force. I would write poems and songs and draw.

I even wrote a children's book. Now with my second son, Nikolas, I feel a peaceful internal force.

I'm more spiritual, and I'm drawn to a more meditative state.

Both boys are so similar yet so different, and I love them more for their differences.

Both are bound by a very similar experience in their birthing. Both times, at one point, there was threat of a C-section.

I didn't want one. I looked up and said the Lord's Prayer, and immediately things changed.

Jovan was freed from distress, and Nikolas finally began to descend and crown.

Watching the births of my sons, seeing them come into the world, was the most incredible experience.

One second they're in your body, the next they're in your arms. Sweet smelling and soft.

I actually love labor more than any other part of pregnancy. Knowing that it's "time" is so thrilling and scary.

But it's magical, because life begins!

~

Nikolas Ruben

Born April 26, 1996

Lanita Mac

Beyond the incredible bond with my husband that has provided such a necessary foundation for me,

this pregnancy has given new life to those around us, offered new roles and relationships for members of our family.

It is this realization, for me, that has been so awakening. Mother becomes grandmother, brother becomes uncle.

And, having newfound respect for my mother, a new relationship has been created. Not only does this child bring love

to my husband and me, but he joins the family together in a new way.

How much a pure, innocent, untouched life can do for us!

It's a foreshadowing: me emerging from this shell as my child will emerge from my womb.

And it's ironic—I must admit that being a dancer, I feel less graceful and coordinated

as I grow closer to the moment of truth. Yet despite the clumsiness and loss of balance, I can happily report that during this

pregnancy, the world is mine! I awake each morning feeling electrified and radiant, invigorated, strong, healthy, beautiful, glowing,

twinkling like a star, and loving everyone around me. Nothing can ruin my day. I share my news with everybody,

accepting people more and feeling more content with myself than I've ever felt before.

~

Harrison Anthony

Born January 16, 1997

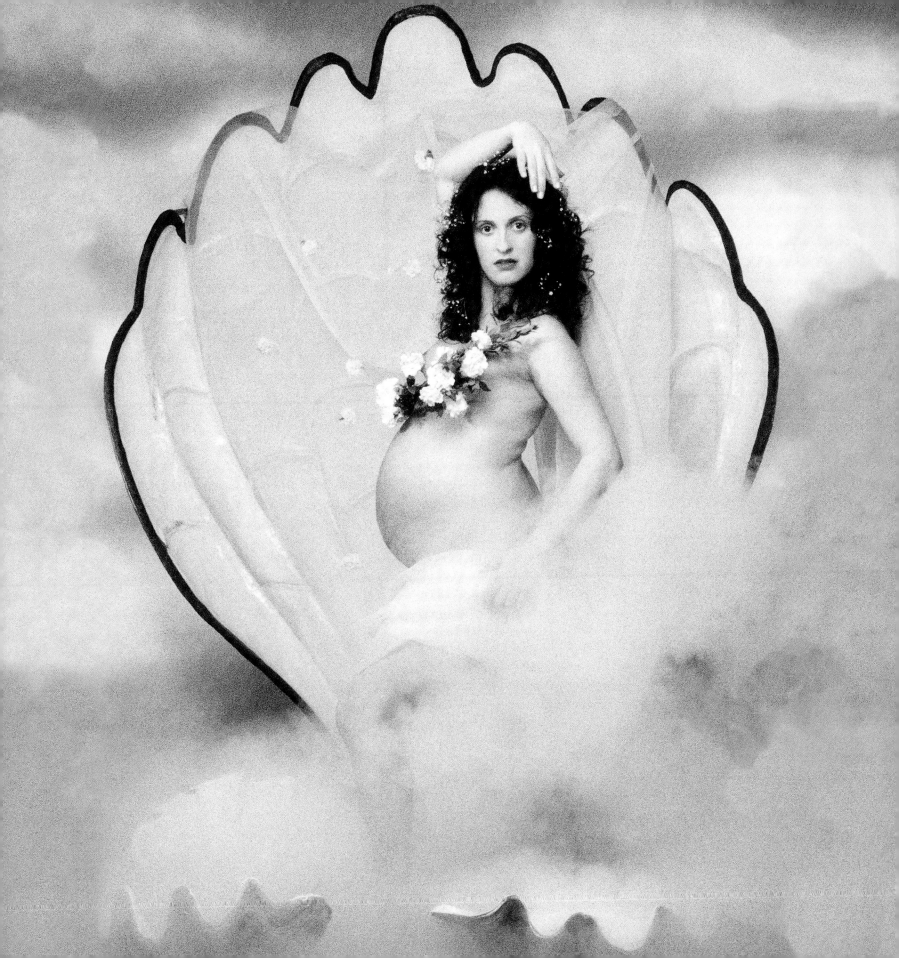

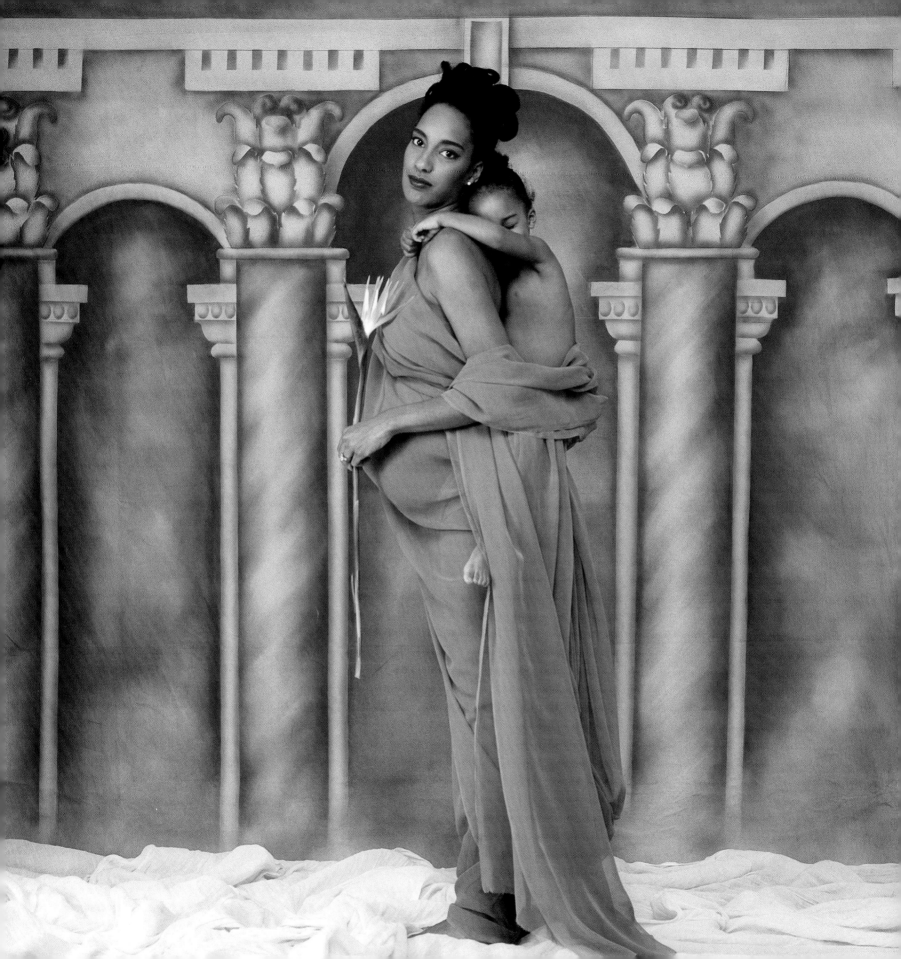

Tiffany Barnes

I have always wanted two little girls. God has blessed me twice!

When my first baby girl, Alexandra, was born, I worried that we loved her too much.

Her daddy and I kissed her fat little cheeks from dawn until dusk, and then some.

When we learned of this second blessing, we were both overjoyed and anxious.

Would Alexandra welcome another little person into our family?

Had we given her enough time to be "the baby"?

As my belly grew, so did Alexandra's love for her new sister.

The only books she wanted to read were about families having new babies!

Every day, she kissed "her" baby in "Mommy's tummy."

At every doctor's visit, she asked the doctor to "take our baby out, please."

When Aren Elizabeth was born on March 27th, I believe a friendship was renewed.

I think my girls were best friends in the baby land of heaven.

~

Aren Elizabeth

Born March 27, 1997

Mae Welter

With pregnancy and giving birth, I experienced a purity of purpose. I felt like a goddess.

Powerfully female, my body was performing godlike miracles. My purpose was pure: creating and giving life,

the ultimate feminine experience. It was simple, absolute, no doing it any other way. It was surrendering to nature's life forces

churning inside my body. Though extremely painful at times, it was physically and emotionally freeing

to receive the changes pregnancy, labor, and motherhood brought me.

Through it all, I finally learned to experience and enjoy life "in the moment."

I never knew how deep love could be until I gave birth to my son and became a mother.

Motherhood has made me feel like a part of the world as a whole. No longer alone, I have empathy in my heart

for every mother I meet. For I know that she, too, has experienced her goddess within.

~

Thomas Joseph

Born June 13, 1994

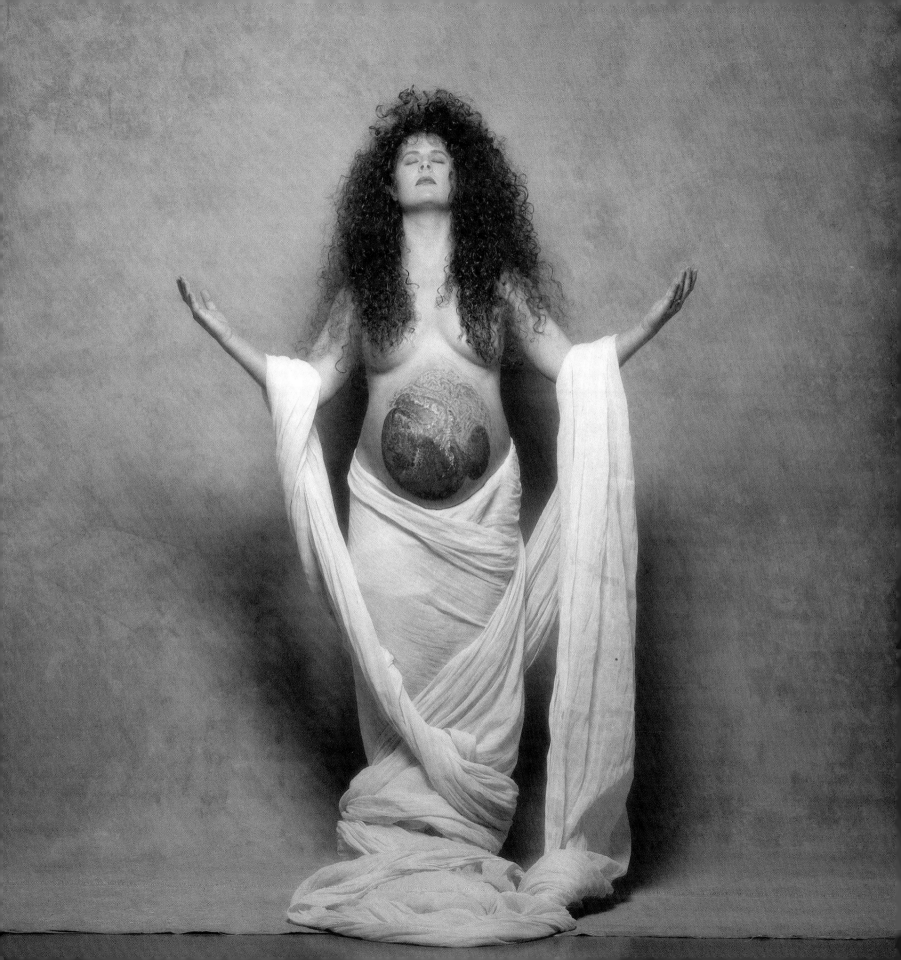

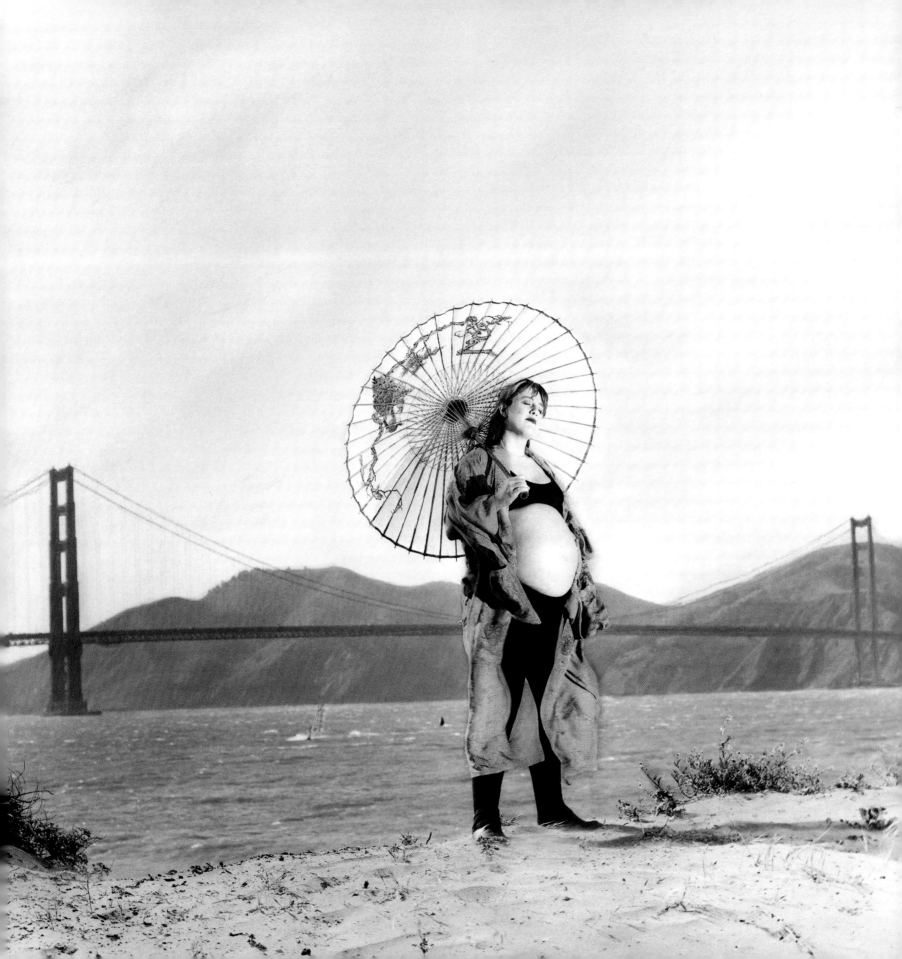

Maggie Cooke

Julia made a dramatic move at a baby shower held in our honor four days after this picture was taken.

My water breaking brought her and Riley into our world six weeks early, contrary to the belief my doctors and I held

that this would be a full-term pregnancy with a long labor.

The journey of discovering my children's identities will be one without end, I'm sure, yet I think I began picking up cues

while they were still in "waterworld": she likes Bach, he Stravinsky; she responds to her father's voice more than to mine.

David and I waited longer and worked harder than many to receive this miracle,

and I am overwhelmed by the depth of my love for these tiny individuals and by my ever-deepening love for their father

as I watch him wrap his large heart around them.

What makes me a goddess? Perhaps it is the ability to provide nourishment and comfort

for these needy ones before providing them for myself. If so, goddesshood is easy.

Julia Louise and Riley Peter are all the reward I will ever need in this life.

~

Julia Louise

Riley Peter

Born April 15, 1997

Peggy Holmes

When I was pregnant, I sometimes felt anxious because I knew I had started down a path

that would lead me to face something that no one could sufficiently prepare me for—labor.

From the very beginning of my pregnancy, I knew that the baby had already decided when and how she was going to arrive.

Once in a while, this sense of being out of control of my body overwhelmed me and I would rely on my dog, Pete, to calm me down.

I would lie in bed at night and call out, "Petey...Petey." He would rush to my side and look at me

as though he understood everything I was going through. Somehow the silent exchange calmed my fears

more than conversations with other women, advice from doctors, quotations from books—anything.

Ironically enough, my daughter, Gabriella, now does a similar thing.

Every morning from my bedroom, she sits on the bed and calls for Petey.

~

Gabriella Leigh

Born October 4, 1995

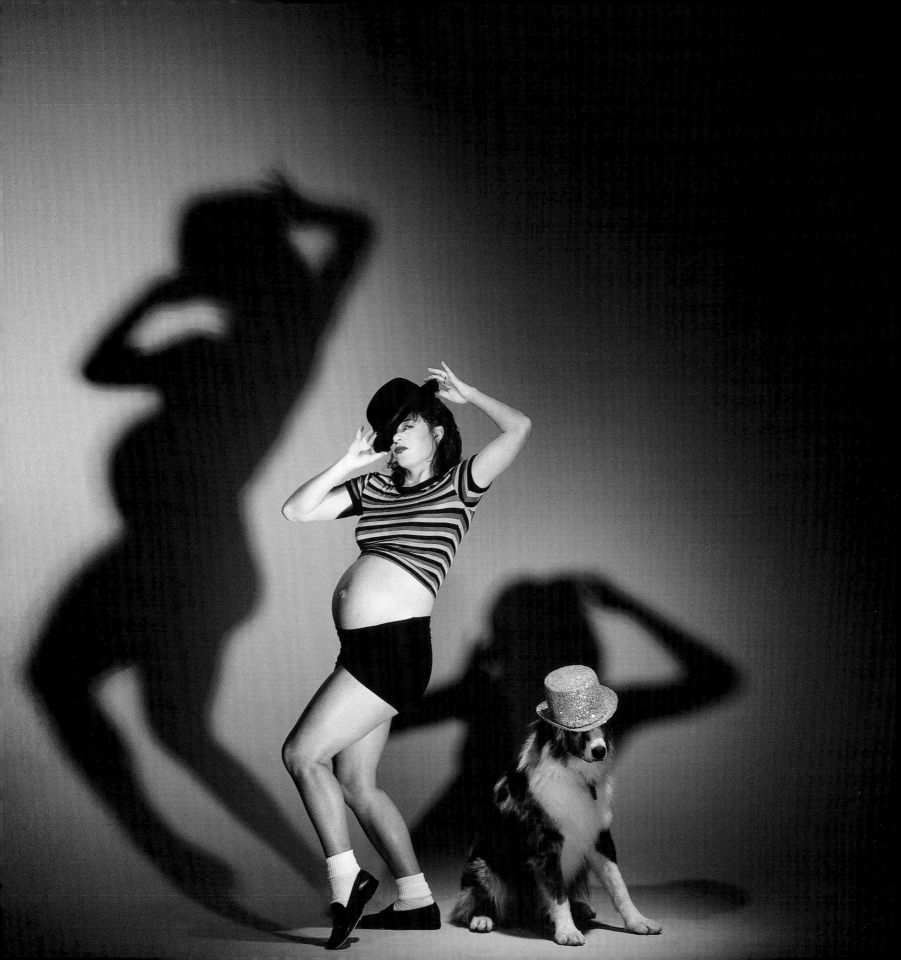

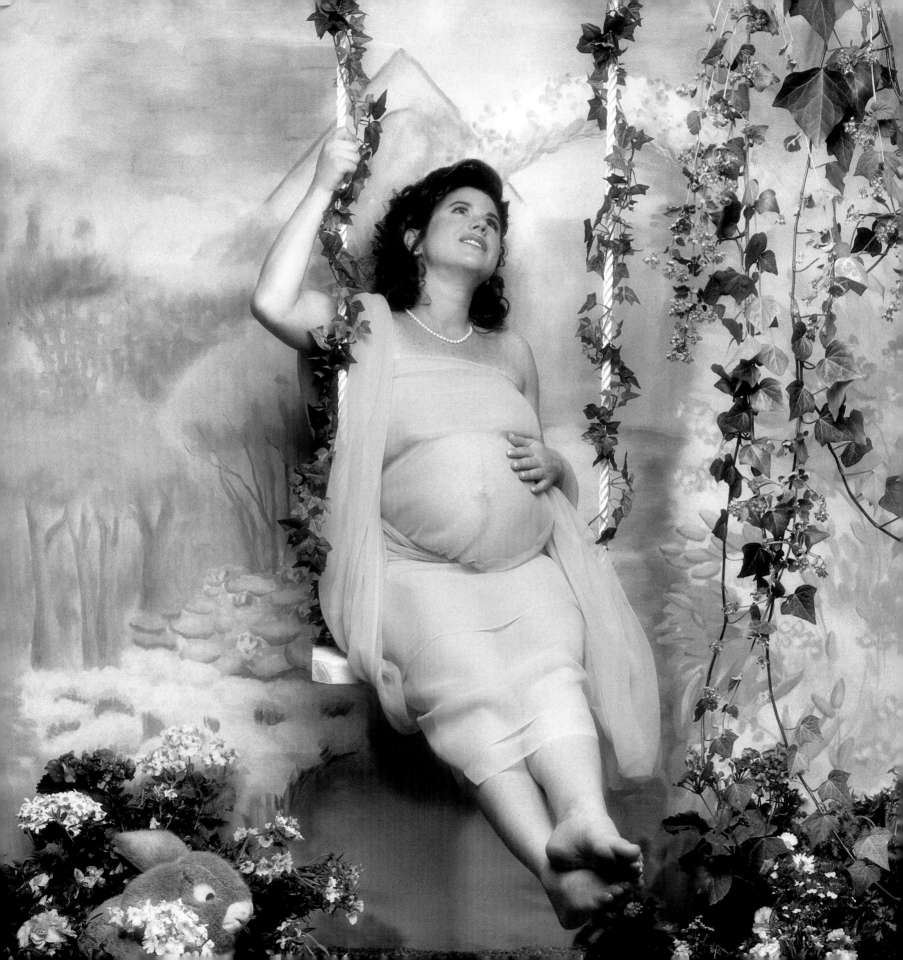

Rachelle Gardner

We haven't yet met face to face, but I feel as if I already know you.

You made your presence known during the first two months when I could hardly keep my breakfast down,

as if you were saying, "I'm here, don't crowd me!"

Only three months along, the contractions started, just a few little ones each day—

already you were impatient to be free.

I tried to keep up my exercise routine, but you protested, not liking all that bouncing around.

Mealtimes are your favorite; you squirm and wiggle with a burst of energy every time I eat.

You are sensitive to your close quarters—if I bend over to tie my shoes,

a few of your well-placed kicks straighten me right up.

You sleep calmly at night, and when I turn over, fidgeting to get comfortable, you do the same.

The sound of your daddy's voice at the end of the day brings somersaults of delight.

Not even born yet, you communicate so clearly.

And your physical strength is amazing!

I've loved getting to know you so far, and I can't wait to hold you in my arms

and begin a lifetime of you and me getting to know each other.

~

Nicole Jean

Born March 24, 1997

Carmen Mancini

I am not an earthy person, but I felt connected with this birth. I rode the wave of life as it happened.

Afterwards, I felt very empty and alone. When I was pregnant, I was never alone.

There was somebody with me, inside. I cried for hours.

This boy, he was easy. He was up and looking around as if saying, "Here I am."

It was ironic that we named him Ray. He came out with clenched fists as if ready to fight the world.

He was an amazing child. Even though I felt such incredible sadness because this was our third child and our last,

we were given an incredible old soul who is perfect in every way.

~

Raymond Eloy

Born March 26, 1996

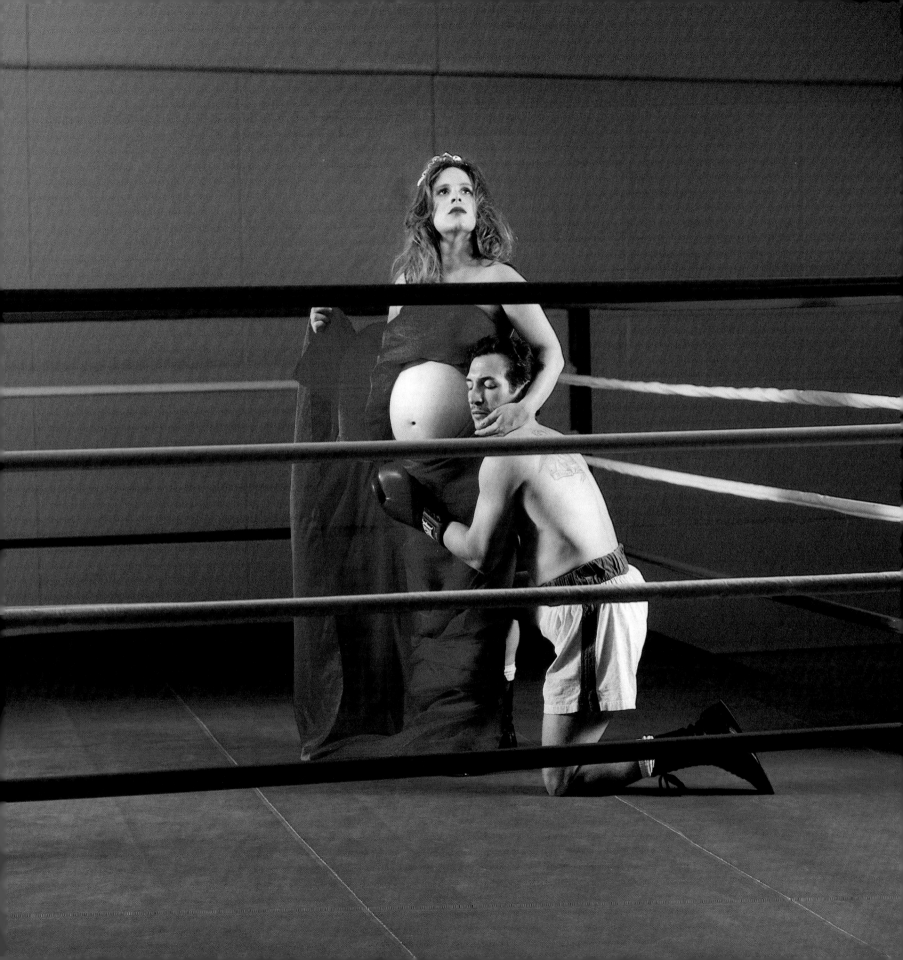

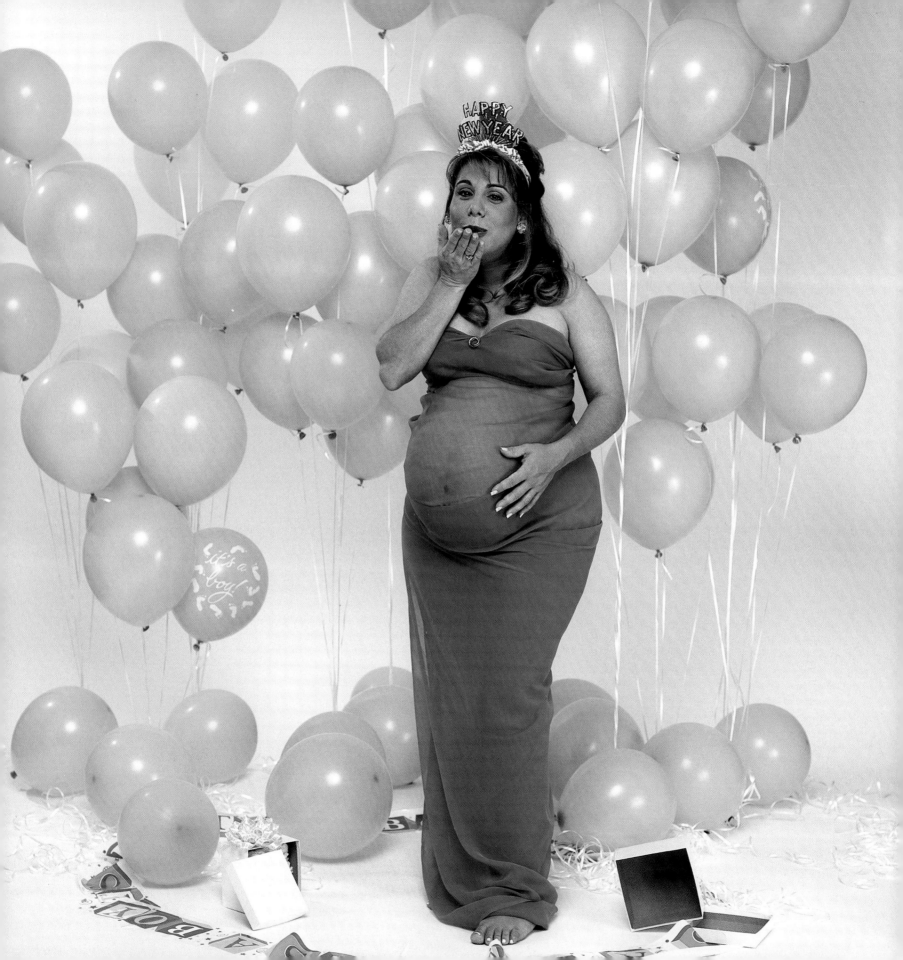

Debi Baer

Are we having a boy or a girl?

It was New Year's Eve. Wrapped up in a box was the answer to that question.

At the stroke of midnight, with our eyes closed tight, we ripped open the box and, between our hands,

we held either a pink or blue pacifier. On the count of three, we opened our eyes and then our hands and screamed with joy:

"It's a BOY!"

~

Jake Werner

Born May 22, 1997

Peggy Etra

The instincts during pregnancy are strong,

to eat, to walk, to rest...

But the strongest urge I ever felt

was of that to nest.

~

AnnaRose Gabrielle

Born March 10, 1996

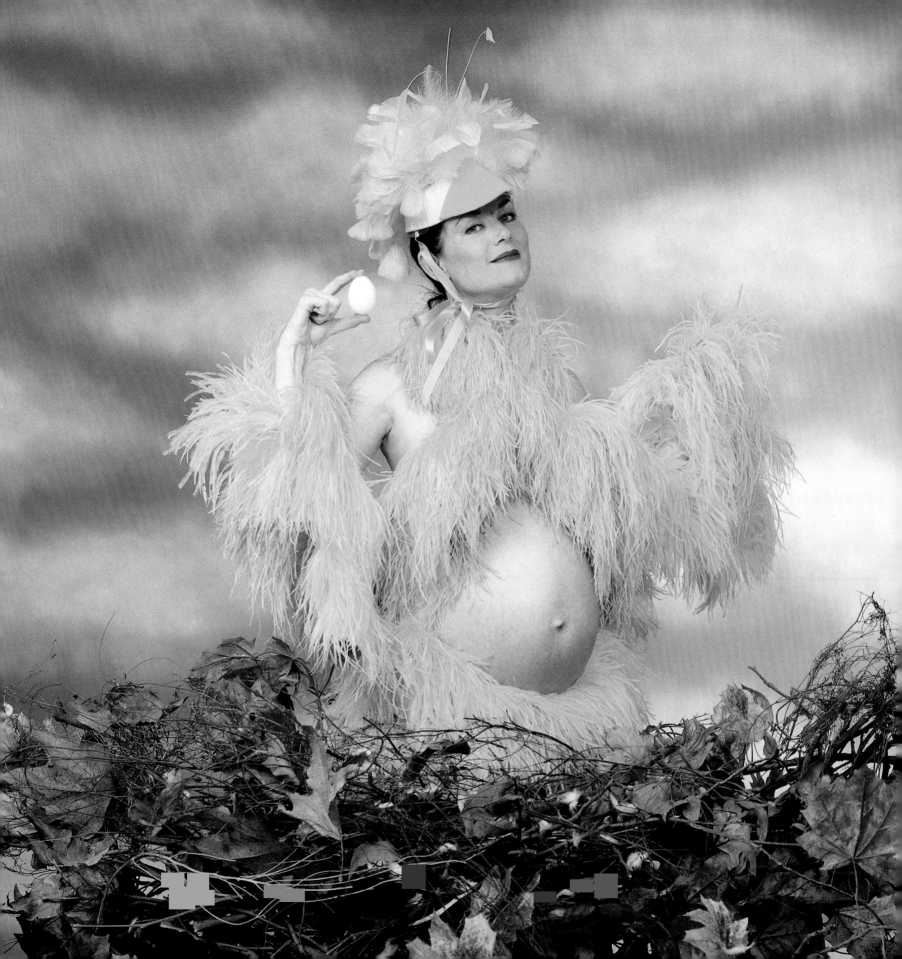

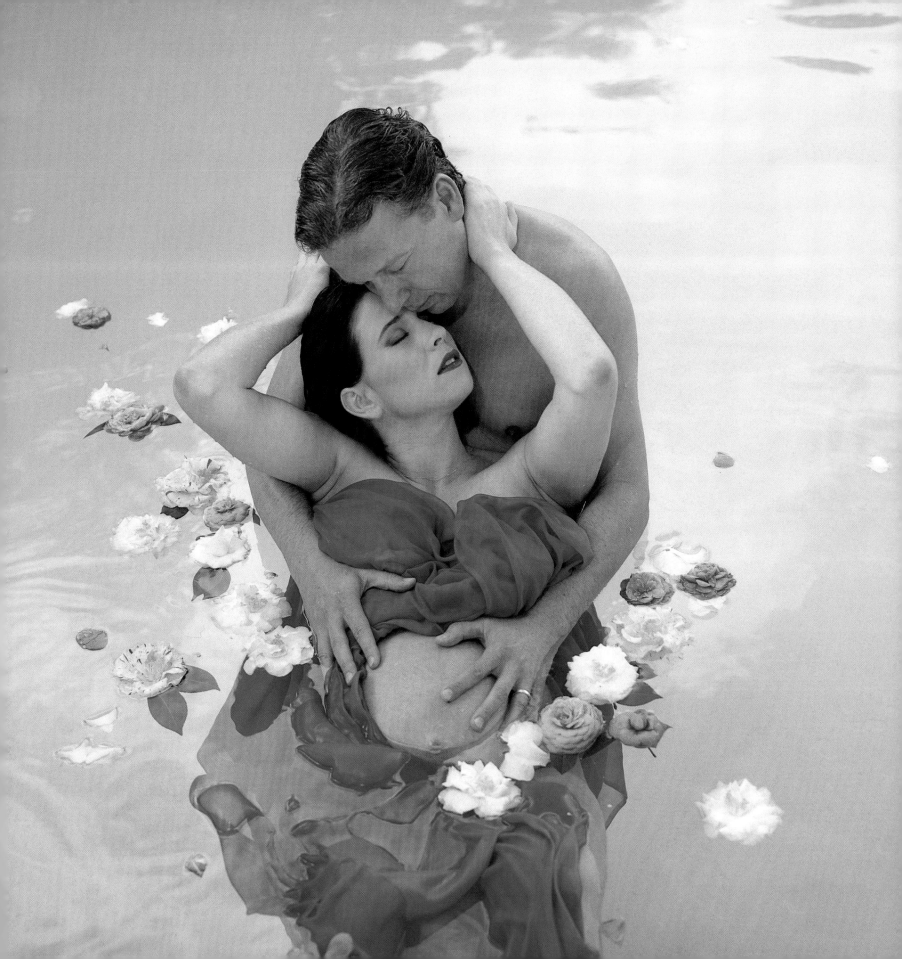

Maura Vincent

"Long you were a dream in your mother's sleep

and then she woke up to give you birth."

—Kahlil Gibran

This quote—sent by a family friend soon after Raina was born—sums up my dream to have Raina in my life one day.

What amazed me most about being pregnant was how my body took over: my mind, my fears, my anxieties, my inhibitions. I watched my body expand, making room for Raina. I felt womanhood fill every part of my being. I felt empowered, as though I were floating. Water has long been a comfort to me, and Raina being born an Aquarius in the Age of Aquarius deepens this connection. There must be a mystical bond between women and water. I suspect that every mother marvels at the flowering of her body as she gives birth; I shall never forget the nine months of unveiling and flowering I experienced in giving birth to Raina. She far exceeds any dream I could have conjured—waking or asleep.

The other part of my dream involved having a partner—a lover, a soulmate. When I met Richard, I knew he was the man of my dreams, with whom I could share my wish for a child. Upon learning his life story, particularly the loss of his first wife, I wished even more to have a child—our child.

~

Raina Francis

Born January 30, 1997

Michele Montano

I would often forget I was pregnant. Especially waking up in the morning, my first waking moments

would be full of thoughts of my pregnancy being a dream. Then I would realize it wasn't a dream. I would be a mother soon.

That was a scary thought.

Pregnancy was both scary and empowering. Being pregnant forced me to face issues about myself and my life

that I never thought I would have to. Knowing there was life growing in me was the most amazing,

wonderful experience I could ever imagine. Sometimes I would look at myself in the mirror and be in awe of the changes in my body,

knowing that my life would never be the same once she arrived.

~

Chloe Alexandra

Born March 19, 1997

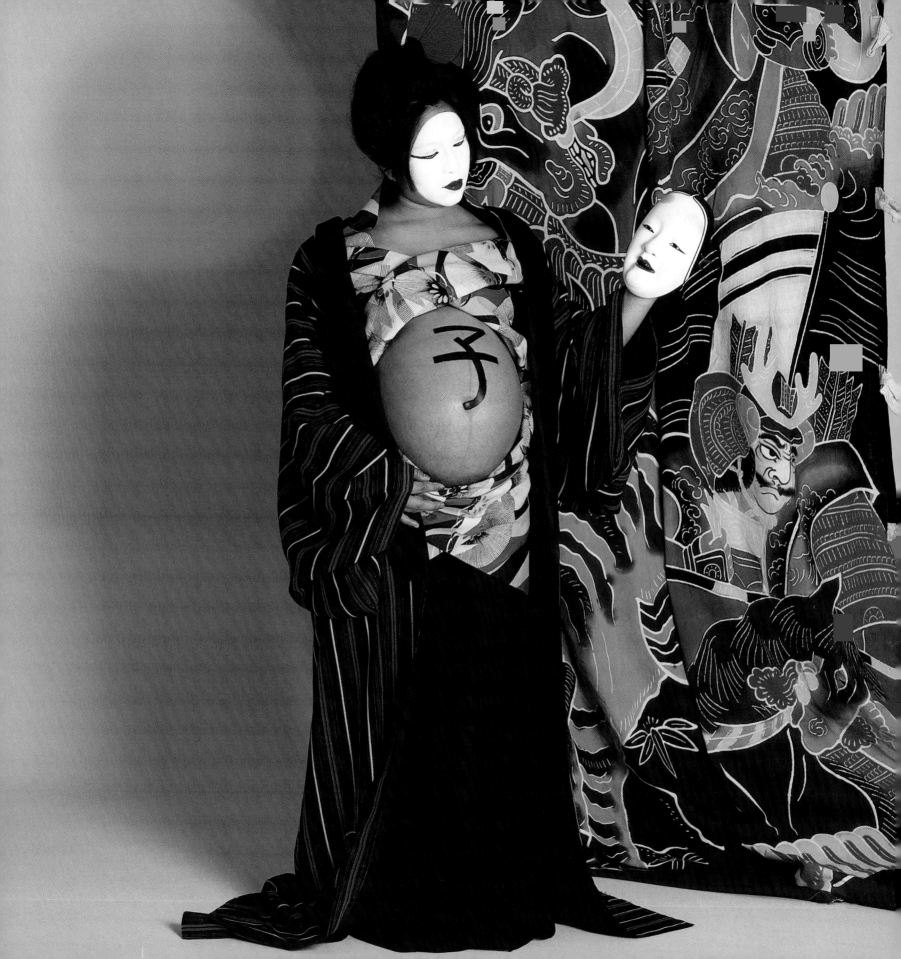

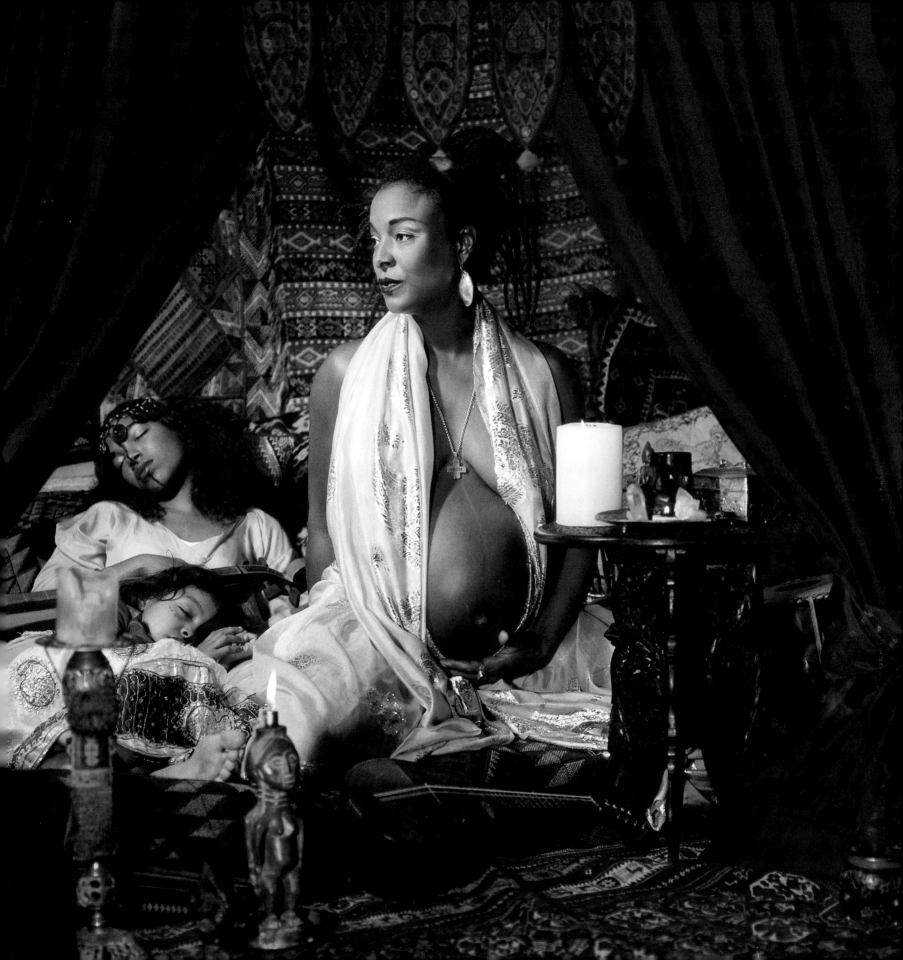

Anedra Shockley Elsesser

In a timeless place with unearthly rock formations standing upright like mountains of the moon, I found my true self.

One brilliant, full-moon night, I met Sego, living among the Saharan dunes and stars in a solitary tent.

Though I didn't speak her language, I understood her well:

The beauty of her is ancient

As the center of the earth

Clan mother

To nations she gave birth

They call her "Tamat"

Beautiful woman

Beautiful in all ways

See her countenance

The depth of her gaze

And what pride

No truth does she hide

She's Tamat

Gazelle of the desert

Swift and free

Woman amongst women

You've captured me

Gazelle of the desert

I must be Tamat

I feel so good inside of me.

~

Sage Gabriel Carlos Atreyu

Born January 31, 1997

Kathy Najimy

I suppose this photograph represents my desire to continue being myself, all of myself during pregnancy and now as a mother. Dan and I decided at the beginning that the greatest gift we could give our daughter was to ask her to join us on our ride through life. So, our commitment is to try to stay true to who we are as we make the transition into parenthood.

My pregnancy was a surprise. I always knew that I wanted to give birth/be a mom, but I could never have guessed it would be right now. Right now! That is how pregnancy felt, and that is how being a mom… forever…feels now. Everything is right now. Pregnancy tests and check ups…right now. New diet…right now. Quit smoking and drinking…right now. Talks, discussions, crying, laughing hilariously…right now. Life-changing decisions…right now. Labor…right now.Contractions, emergency procedures…right now. The baby is here…right now. Crying…right now. She needs to be fed…right now. Store milk…right now. She needs to be changed…right now. She is making a new adorable face, look…right now. She is growing…right now. And our love for her grows and grows as she does, right before our eyes…right now.

It was so clear to both Dan and me that we had little to do with the choice of this baby being born. We remember the day. It was as if she was willing, insisting even, that we do whatever was necessary to allow her to be conceived. She won. We won. Right now. Here she is, and at the risk of sounding like a sappy Hallmark card…it is a miracle.

~

Samia

Born December 12, 1996

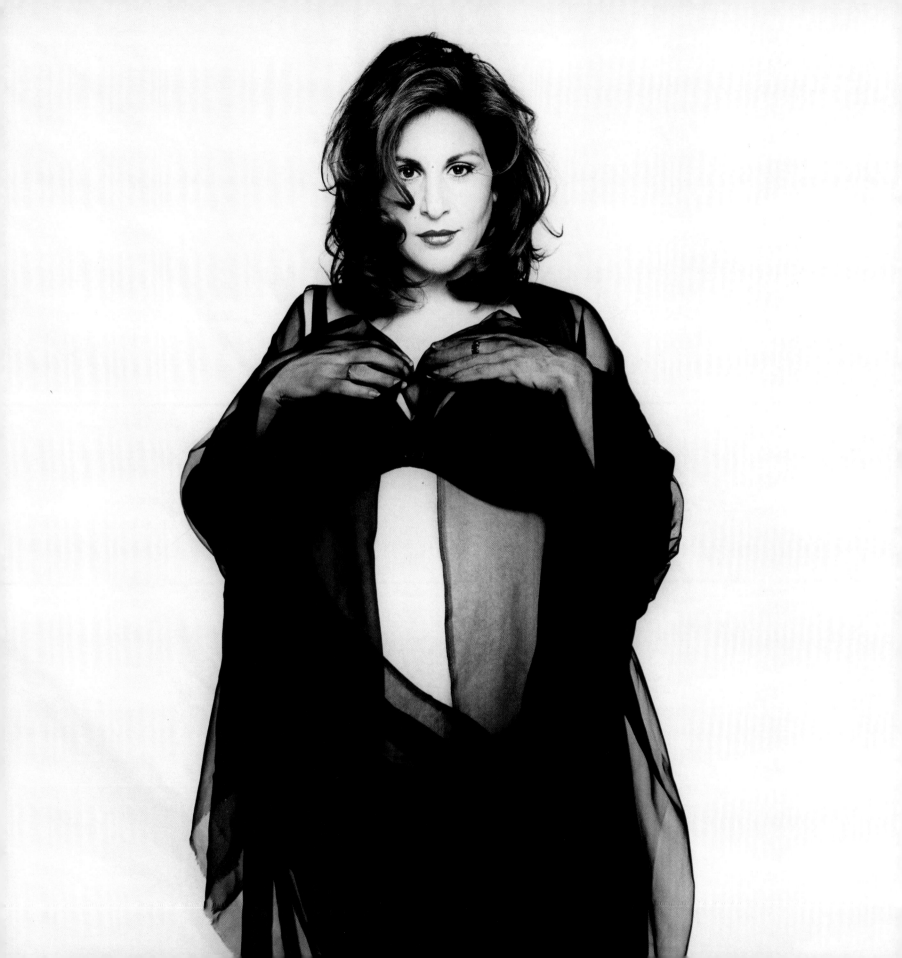

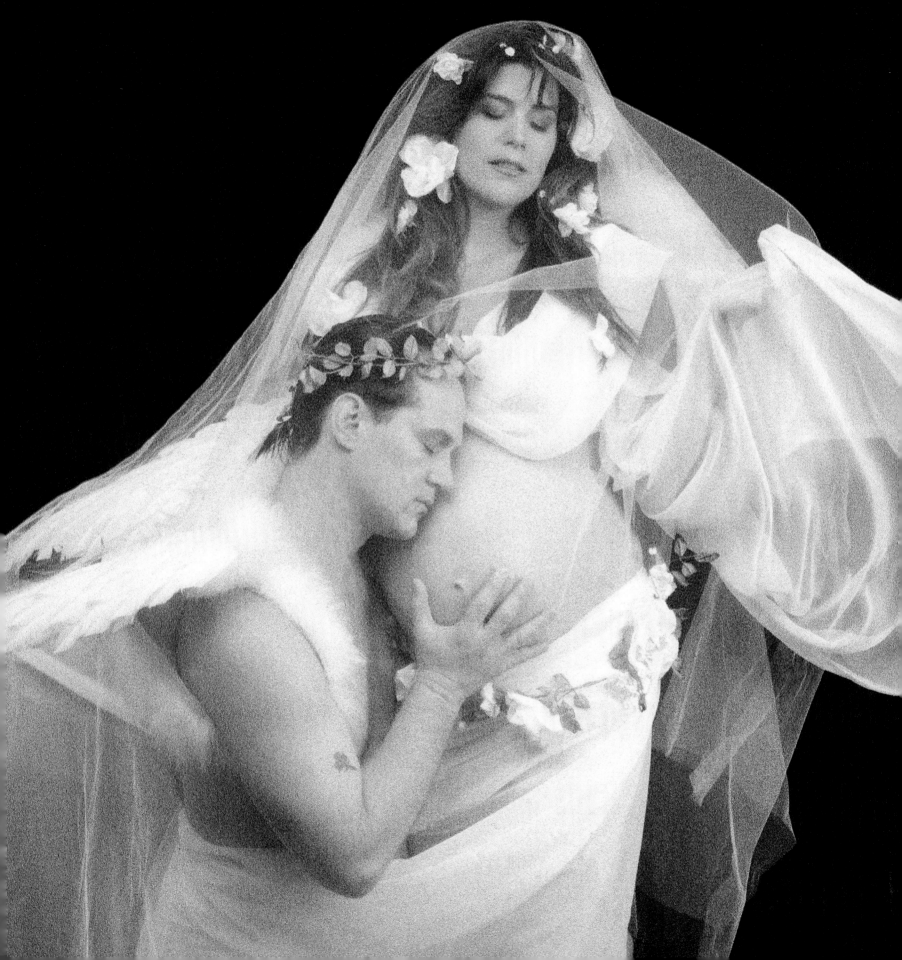

Michelle O'Kane

Even during such an extremely vulnerable time for us personally, personal was not how it felt.

Love, being effortlessly present, opens the vast window of the mind,

revealing fertile psychic nebulae from which hopes and dreams can be conceived:

Feeling the body as an expression of nature

Experiencing the change as one may experience the many seasons

A period of hibernation

Going into the silence

The eternal peace

Being, and thus being present

To witness a new life emerging

Like watching flowers bloom in spring

A miracle, a celebration, an honor

A gift.

~

Kaitlin James

Born September 27, 1996

Judy Mihanovic

After 37 weeks of being pregnant, I have finally come to accept the fact that pregnancy is governed by the laws of nature.

Just as a brisk, cloudy morning can clear to a glorious, sunny afternoon, pregnancy involves an unexpected state of mixed

emotions: joy and exhilaration at the thought of carrying this little being inside me…fear and anxiety at knowing

I'll be responsible for something until the day I die!

~

Joseph Luke

Born March 11, 1997

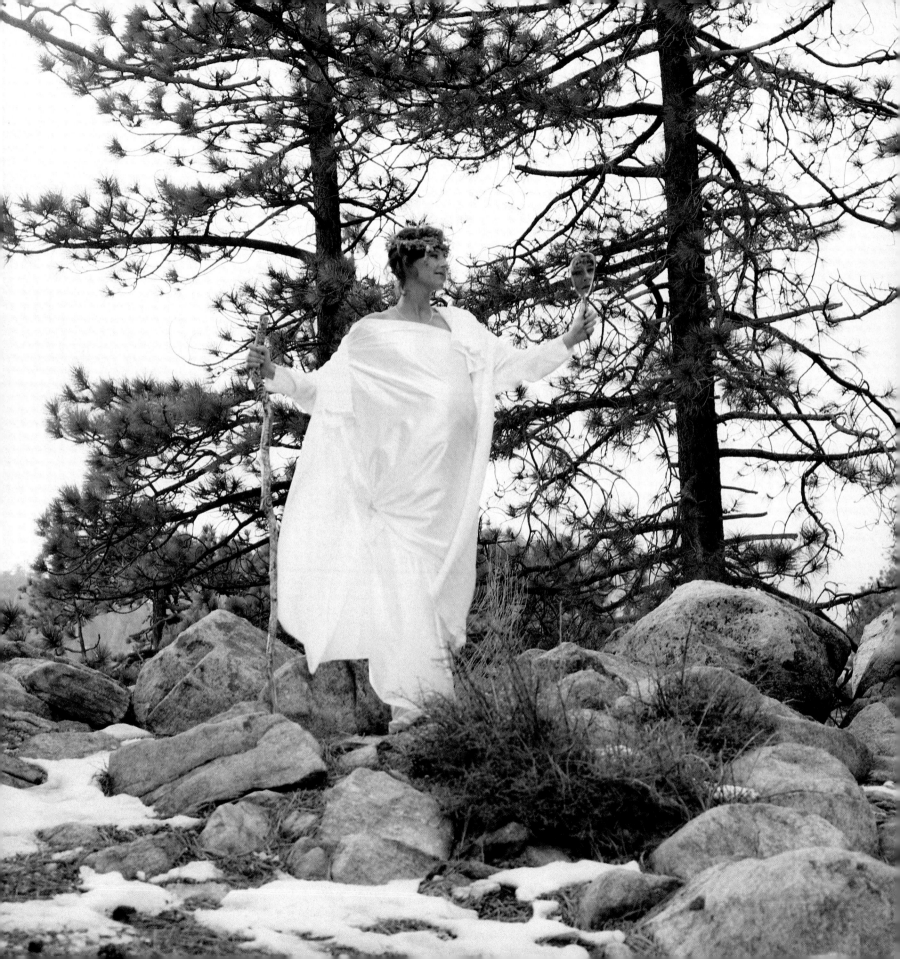

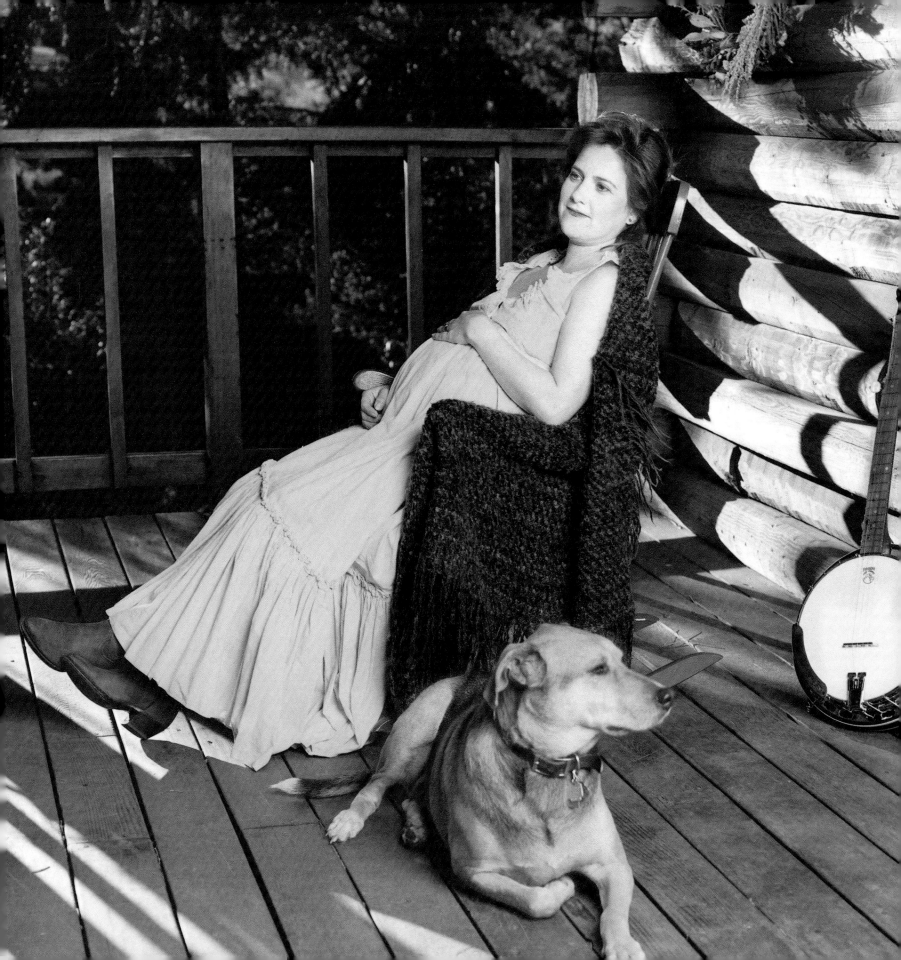

Dawn Walnoah-MacRecknie

The idea of pregnancy was the most daunting thing in the world to me.

I wanted a family, but I also wanted to keep my career on track. I worried about the discomfort and pain of pregnancy.

But most of all, I worried about the life changes that would occur (and that I couldn't anticipate) as a result.

Being pregnant ended up being the most natural thing in the world to me.

Seeing my body change and experiencing all the things that went on inside me

was a fantastic voyage. My body looked resplendent and felt glorious—though that last month seemed to be a test!

Instead of feeling fat, weak, and ugly, I felt energetic, powerful, and beautiful. Knowing that this moving, kicking, hiccuping thing

within me would soon be a living, breathing, separate being was incomprehensible—

yet completely natural and invigorating.

Whether my pregnancy caused it or not, I don't know,

but I no longer worry about the life changes I will be facing. Bring 'em on!

~

Collin Sage

Born February 17, 1997

Gosia Probosz

Ocean—eternal womb—is my beloved element ever since I can remember.

Whenever I am sad, I walk by its great waters and feel my tears wiped away by the coming and going of its waves.

When I am happy, I share my joy with its fathomless depths.

Its power gives me strength to go on and charges me with its inexhaustible energy.

When I felt my baby move for the first time in the ninth week of my pregnancy,

it was as if tiny fins were flapping in the amniotic waters of my belly. My being pregnant created an oceanic pool of love

within me, a little dolphin dancing and jumping in its waves. I experienced the divine miracle of creation

and became Goddess of the Ocean—where all life begins.

~

Valentina Tulum

Born April 13, 1997

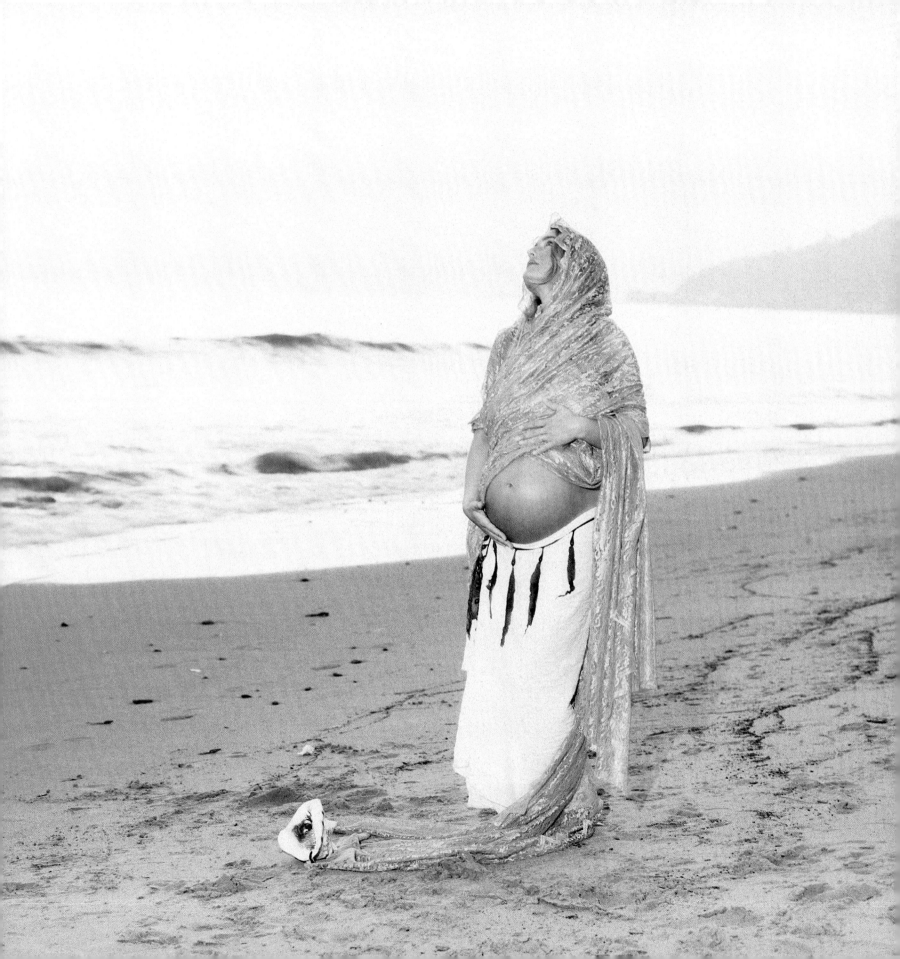

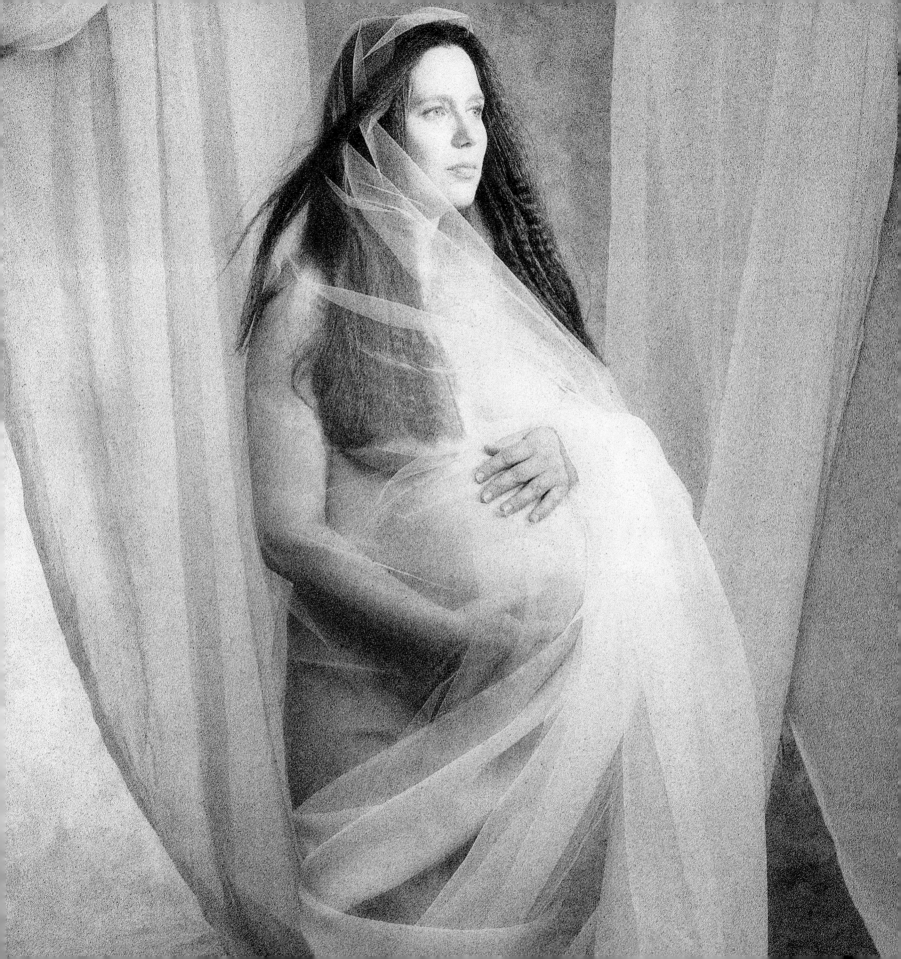

Susanne Degher

The glory of pregnancy. The wonderful experience of transcending your individual self into the universality of becoming a mother.

On this journey, you feel as if you are someone else or are yourself but on a higher, more spiritual plane.

The wonder of the growing baby in the womb. The feeling of understanding it all, if only for an instant.

To see the connection of everything. To see and feel the love. To understand for a moment what life is all about,

how we are all connected to one another through the creation of a new little human being.

To have had the privilege as a woman to experience this extraordinary journey of pregnancy.

How lucky I am.

~

Cleopatra Ingrid

Born May 7, 1992

Heather Ann Lasting

Dear Liam Nicholas,

The breath of life

contains the power of the stars

and joins your world to ours.

Our lives have touched before.

Together, our light

will transcend the past.

With all our love,

Heather and Michael

~

Liam Nicholas

Born September 19, 1995

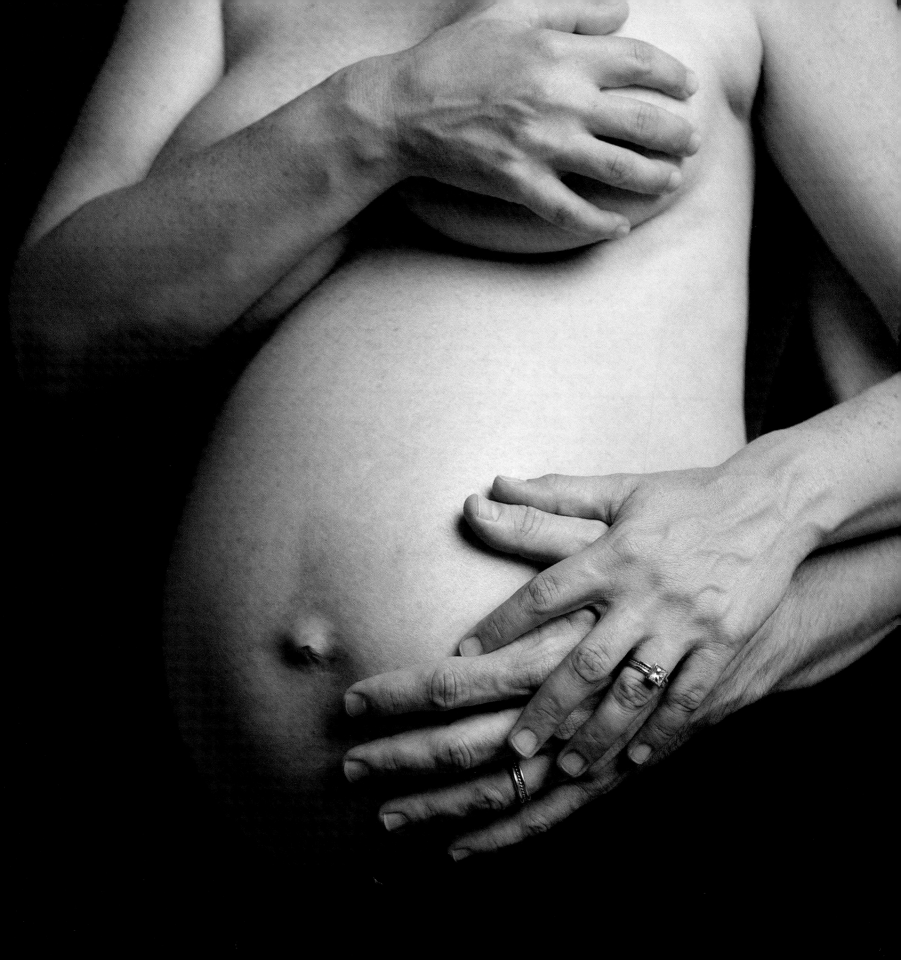

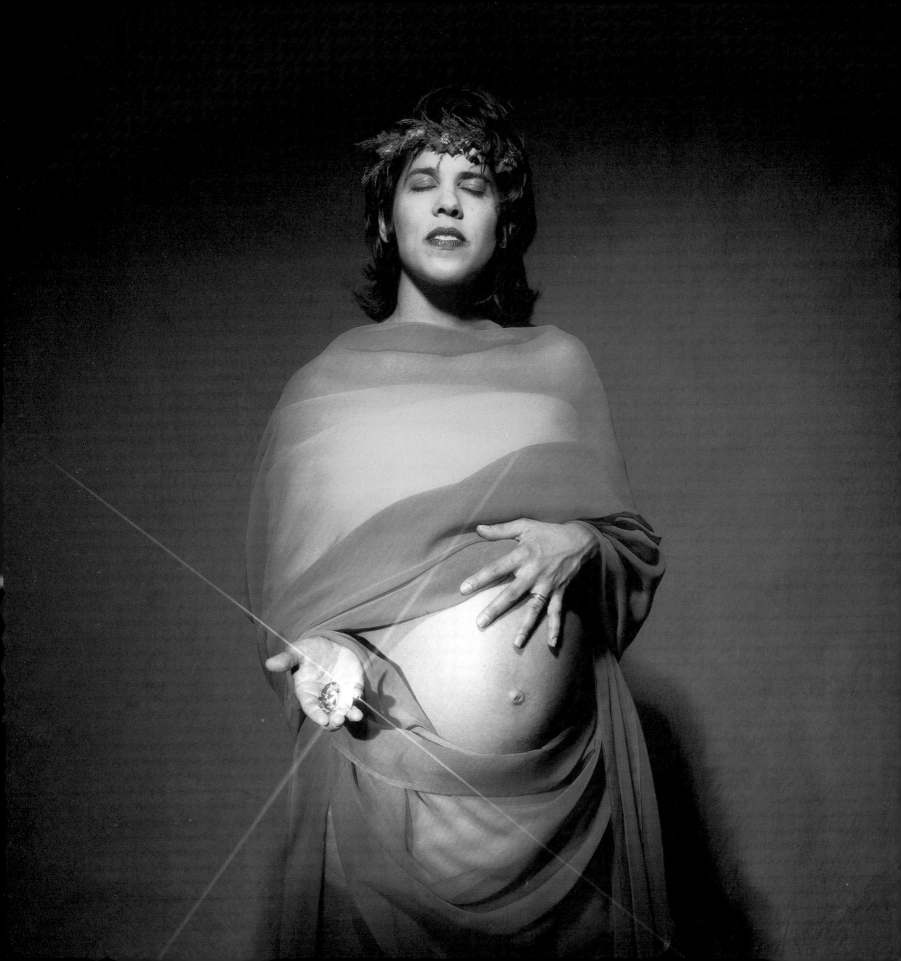

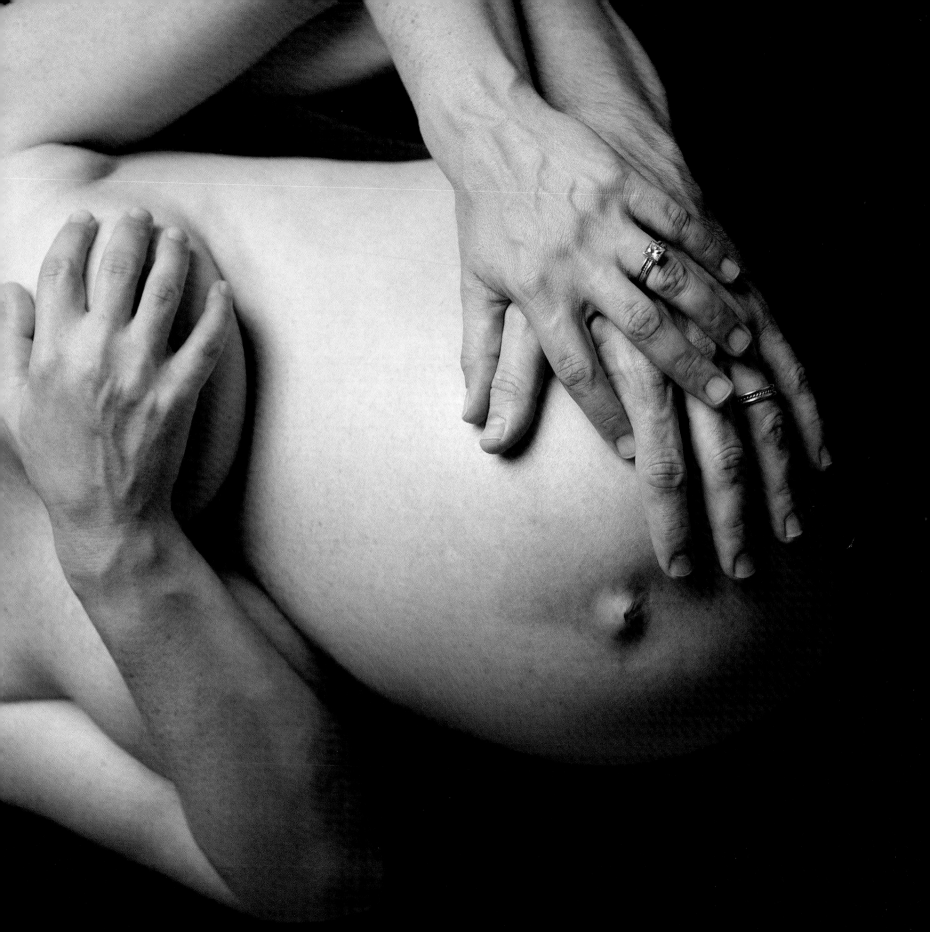

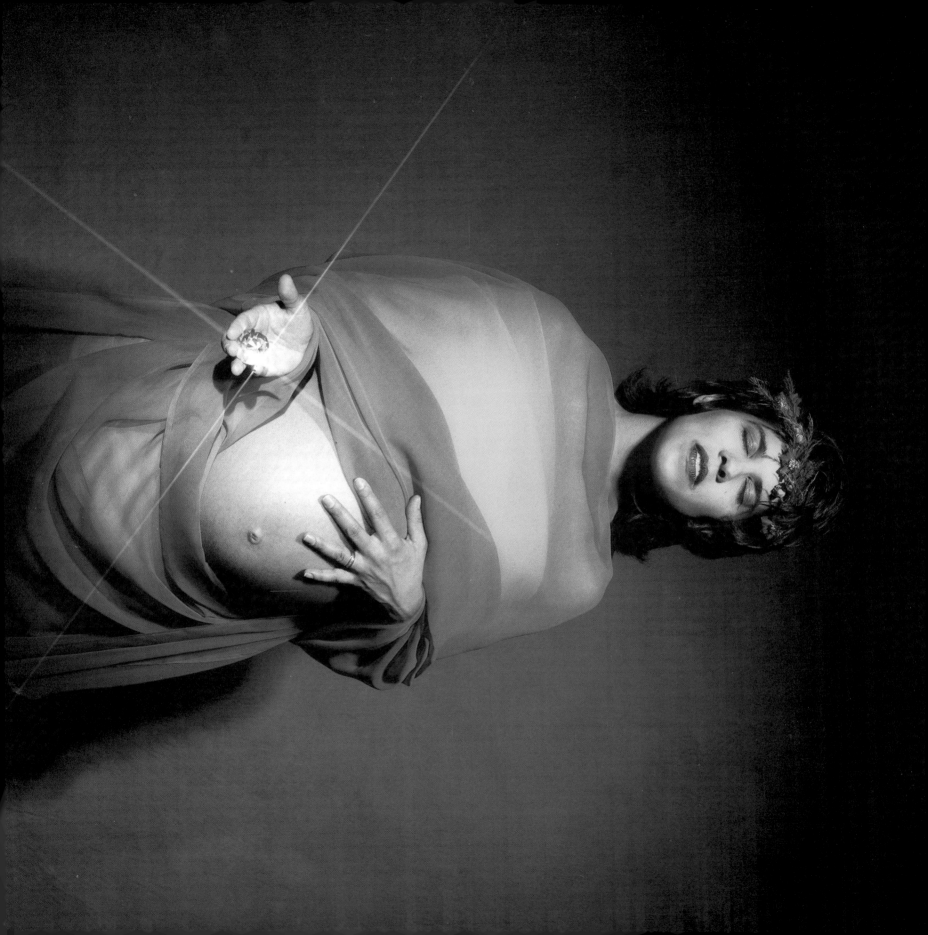

Cindy McGrath

I will never forget the day this picture was taken, because it was the day my son was born.

I gave birth to Jack William McGrath just five hours after this picture was taken. I had rescheduled the shoot so many times that

by this day, October 3, 1996, my body was well at the mercy of the last stages of pregnancy.

Mary Ann would wrap me all up and light me perfectly and then have to wait while I went off to the bathroom.

I was trying desperately to feel glamorous, but instead I felt like a puffy-faced, bloated woman

with a 30-pound water sack hanging from her middle.

Mary Ann finally said, "OK, we're done," and we broke for lunch.

That's when I discovered that more than one thing "broke" for lunch. I ran from the spot, pizza in hand.

Pizza was still on my mind as I lay in labor. I had read that you should not eat before labor, and now I know why.

Jack was so anxious to get here that there wasn't time for an epidural. His mommy's yells greeted him

as he entered his new world. And so ended my pregnancy. My father died suddenly early on, and because a period of bed rest had been

mandated for me, I missed my father-in-law's funeral. Now as I hold my beautiful baby boy,

I want to hear what his two grandfathers may have whispered to him on his way here to me.

~

Jack William

Born October 3, 1996

Carrie Wilmer Davich

Babies are miracles. I'm lucky enough to be experiencing this blessing for the third time,

while watching my sister experience it for the first. It's been fun to share our joys and complaints —

I so look forward to watching these babies grow up together!

~

Laura Genevieve

Born March 7, 1997

Jennifer Wilmer Miller

This being my first pregnancy, I really didn't know what to expect for the nine months I had ahead of me.

Whenever questions came up, I was very lucky to have a sister who is also my best friend.

This being her third baby, she always had an answer for me. I loved being pregnant but, even more,

I couldn't wait to be a mom...my dream come true.

~

Eric Daniel

Born February 28, 1997

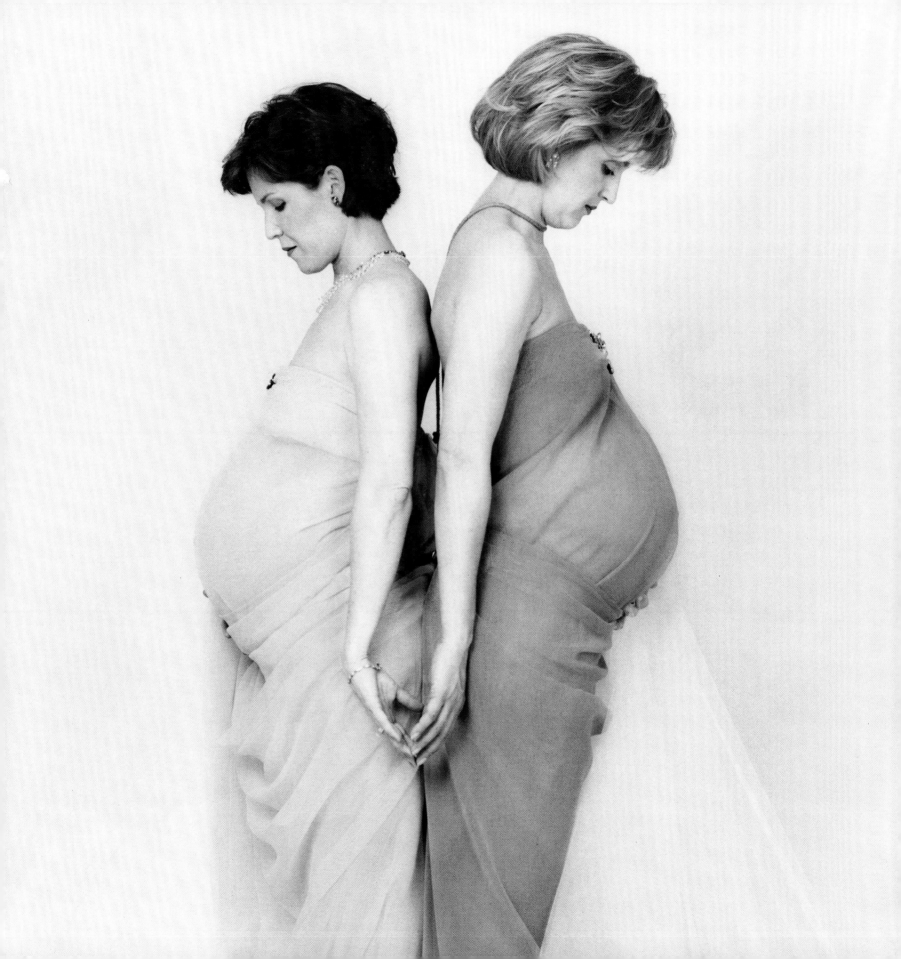

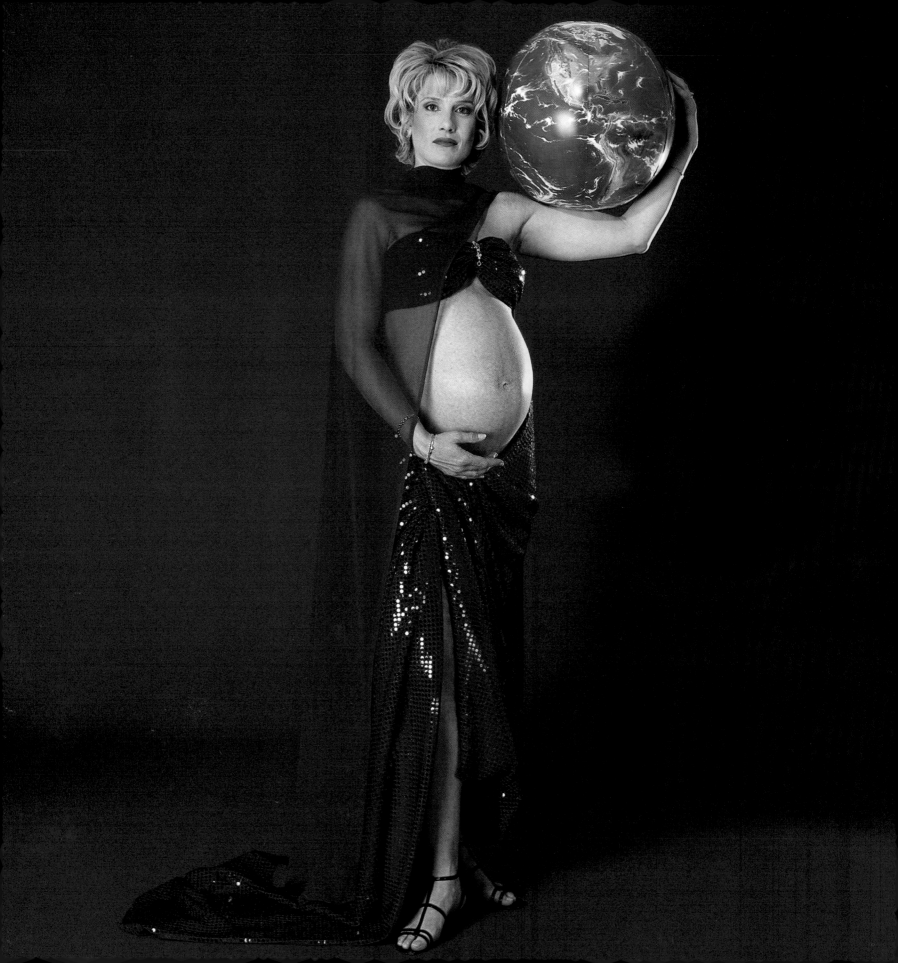

Diane Davis

Pregnancy has changed my whole outlook on being a woman.

Making life gives you the courage to live life. I feel unstoppable, as if I could conquer the world.

For the first time in my life, I know I can have it all:

a healthy and loving relationship, a successful career, and the joy of motherhood.

Pregnancy has given me newfound belief there is a higher power.

Every time little Mark Ryan kicks, I know I've been blessed with a miracle,

and I thank God I'm ME!

~

Mark Ryan

Born May 25, 1997

Hilary Shepard Turner

Last night I dreamt

I was a pregnant mermaid

Floating through liquid love

Light...(Peaceful...Buoyant...Alive!)

At peace in my watery womb

Just like the baby growing inside of me...

When I awoke from the languid lullaby

Only one thought puzzled me...

How does a mermaid get pregnant, anyway?

~

Scarlett Rose

Born May 22, 1997

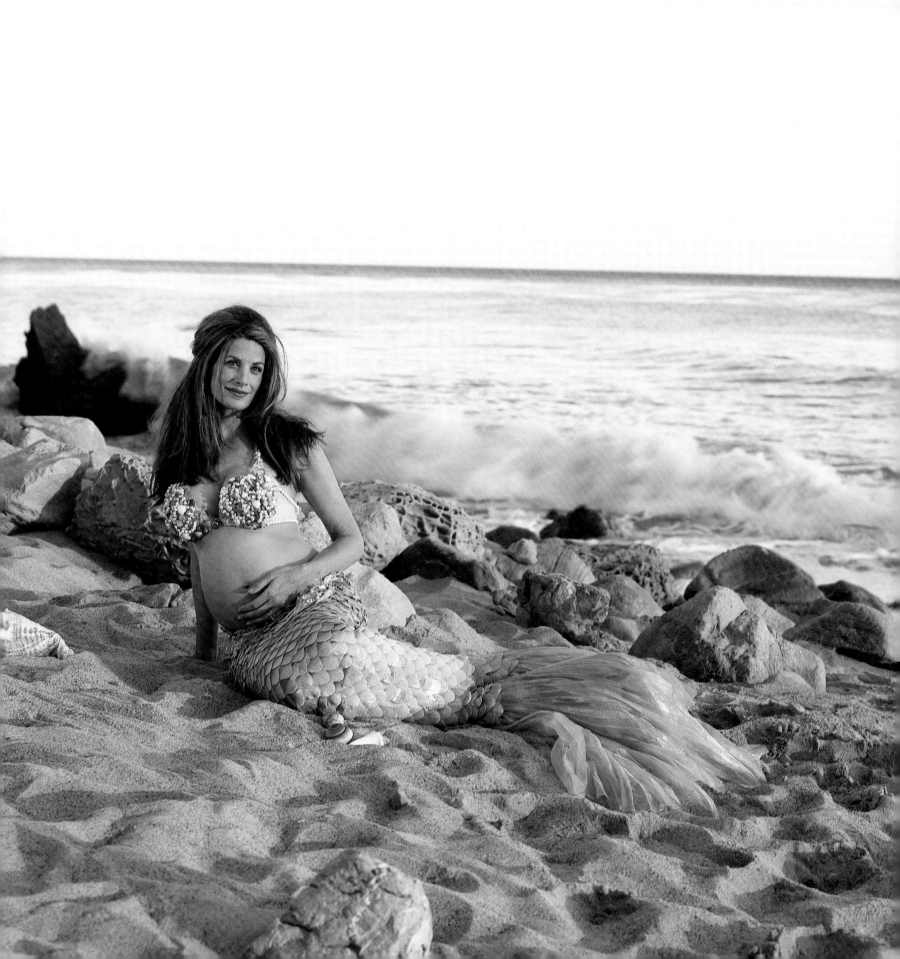

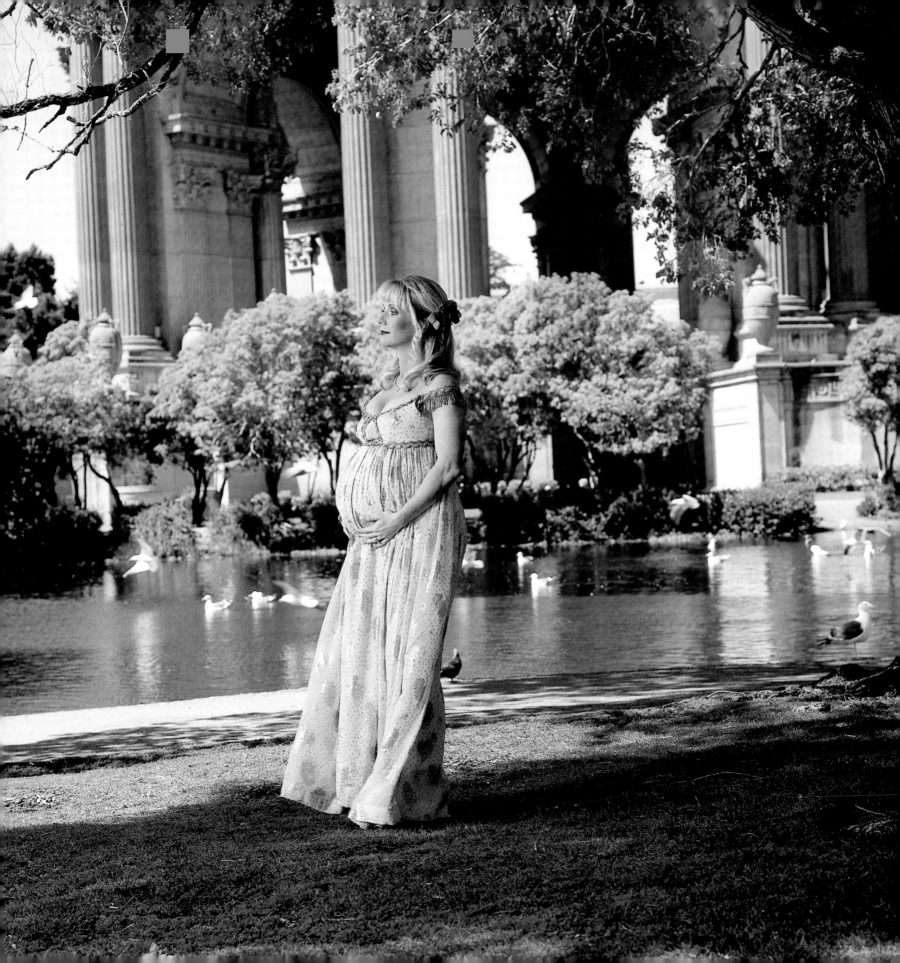

Marcy Elizabeth Peck-Rohn

When I first realized I was pregnant, I had no idea how wonderful and empowering the experience would be.

Now that I am in my ninth month and just a few weeks away from giving birth, I am filled with excitement

and the wonder of you, my little bundle of joy-to-be. I've had an inner peace with you in my womb

for the last nine months that is indescribable. Your presence has filled my heart with the joy of life and new beginnings,

and most of all, with a great deal of love. I am anxiously awaiting your arrival

and cannot wait until my eyes meet your eyes for the very first time.

A baby is truly a gift of love.

~

Madison Elizabeth

Born May 3, 1997

Brenda Isaacs-Booth

Creation! Life! Such a wonderful miracle. To prepare the mind and body as a garden for the planting of the seed.

The days of being a wild weed are gone. Time to come back to earth — to nurture the precious miracle inside me.

I am finally ready to give instead of take.

Each day, I stare in awe at my ever-changing womanliness. The joy and anticipation are immense.
Each time I feel him move, I marvel at my creation. Minutes and then hours are spent daydreaming of holding him in my arms,
lovingly gazing into his eyes, rocking gently with his tiny mouth suckling my breast.

What will he look like? Will he have my husband's warm smile, my eyes, long toes like both of us?
Will he want to be an actor, a poet, a philosopher, a therapist...? I'll be something I've never been but have always longed to be:
MOM. Each day I vow to thank God for this gift — my son, Liam.

P.S.: I was the only one in my Lamaze class who wanted to have "natural" childbirth, without medication.
After 13 hours, I was screaming for drugs...1 1/2 hours later, I screamed for an epidural...then 2 1/2 hours of pushing —
only to end up with a cesarean! (For a total 22 hours of labor.) But, I assure you, he is well worth it!

Do you think any of this has to do with that bite of apple?

~

Liam Elliot

Born May 6, 1996

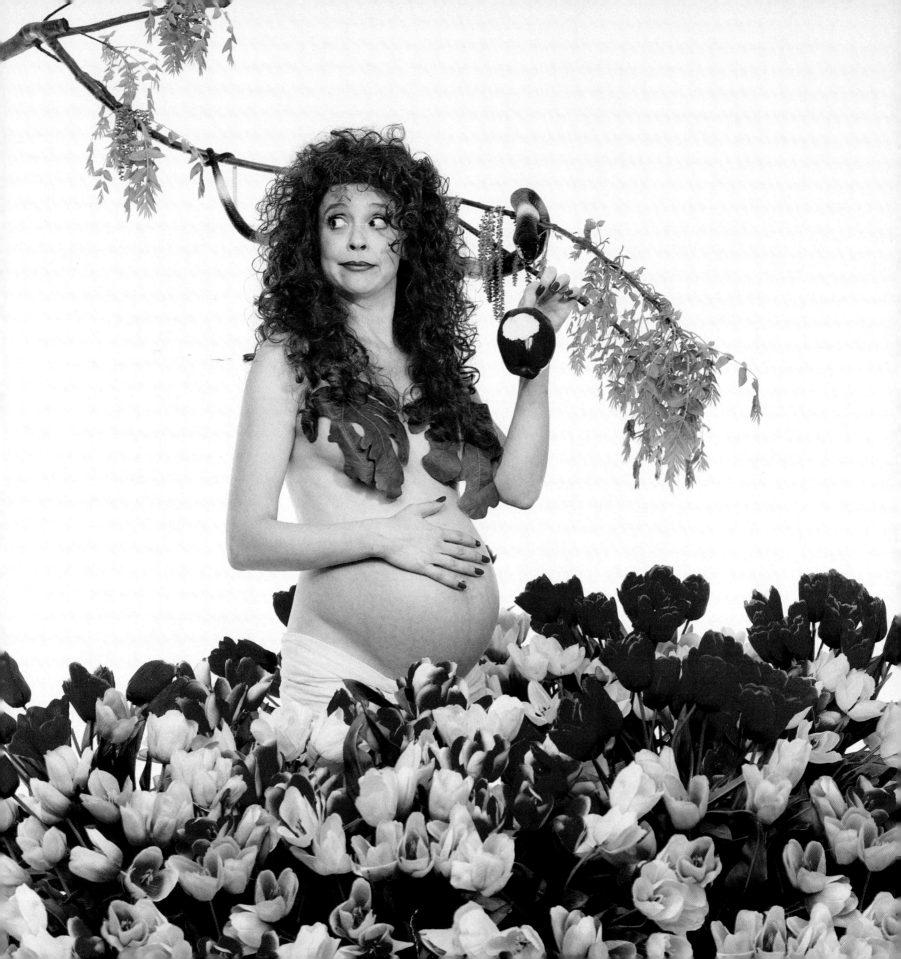

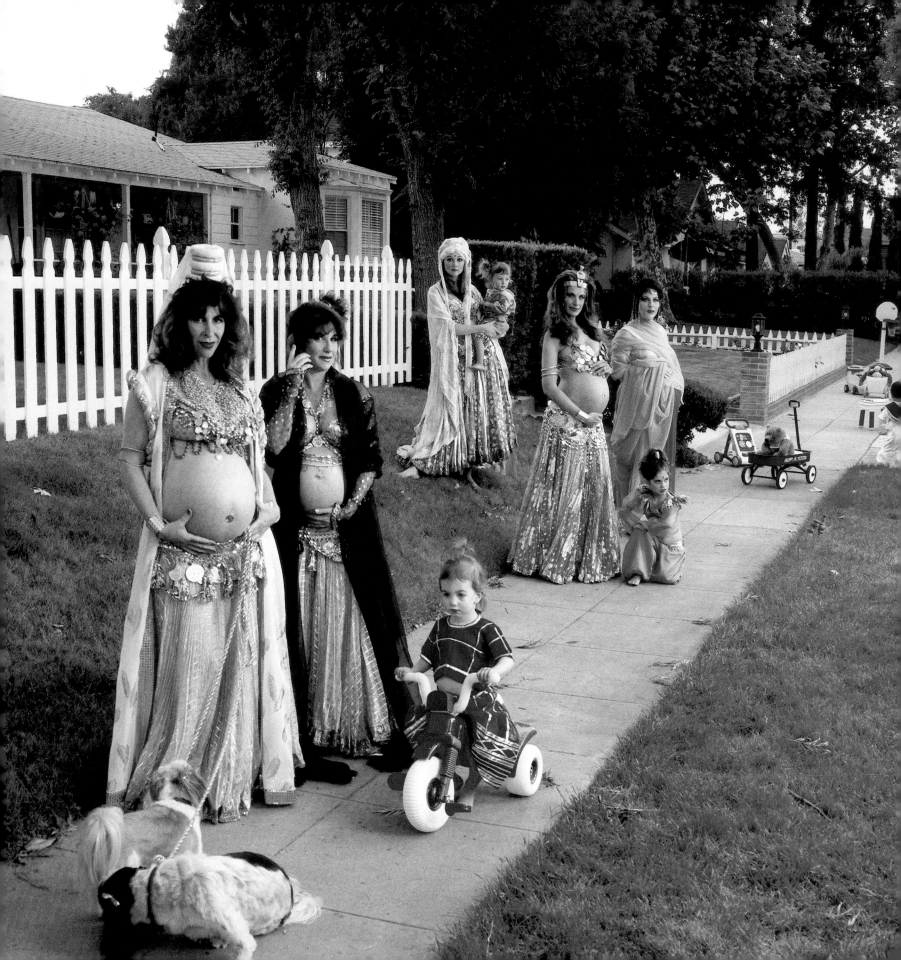

The Goddesses
of St. Clair Avenue

Is there something in the water?

~

Randy Thomas, mother

Rachel Morgan, child

Born May 27, 1997

~

Julie Ross, mother

Danielle Hailey, child

Born May 29, 1997

~

Hilary Shepard Turner, mother

Scarlett Rose, child

Born May 22, 1997

~

Alicia Ezpeleta, mother

Alexandra, child

Born March 19, 1997

~

Jan Porush, mother

Hannah, child

Born May 10, 1997

Gracie Moore Poletti

The first three months of my pregnancy,

every time I had a dream about giving birth,

I dreamed I was delivering a litter of kittens.

I told my cat I was going to have a baby,

and she said, "Don't worry. I've been through this.

We'll keep him in a nice warm cardboard box near the heater.

Then, in 8 to 12 weeks, we'll go sit in front of the market

and see if we can find him a good home."

I don't know how to break this to her, but we're keeping this one.

~

Cameron Michael

Born June 9, 1997

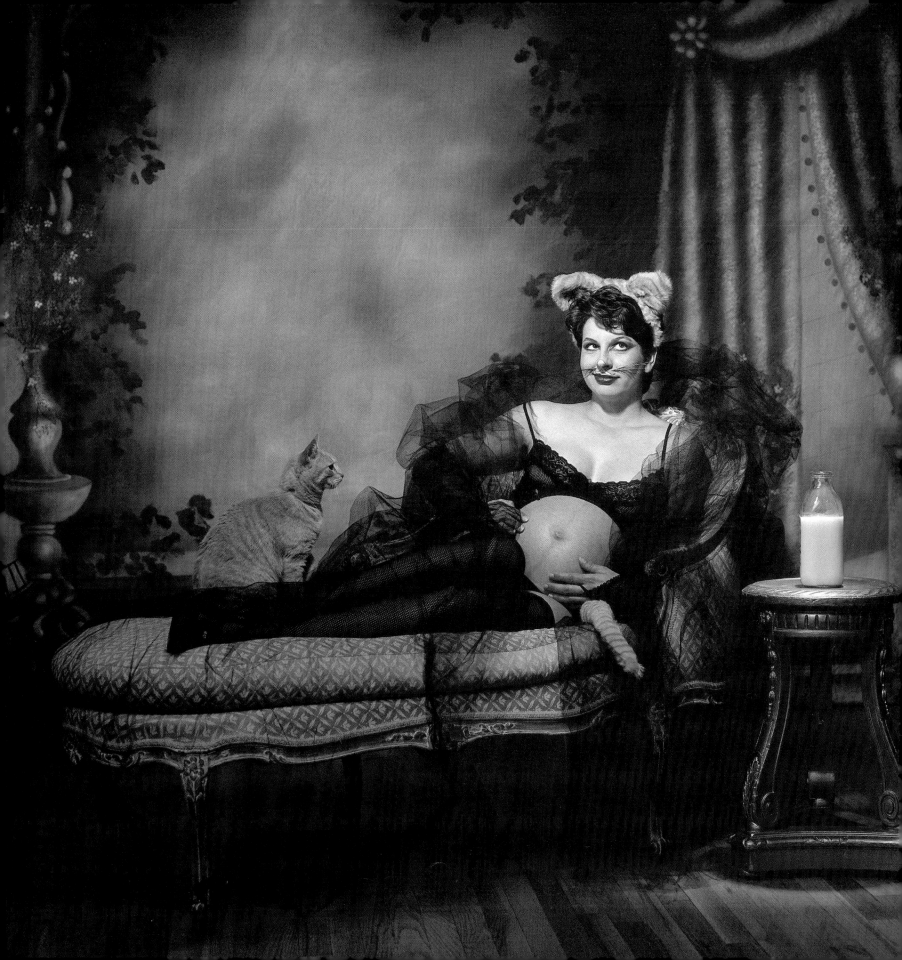

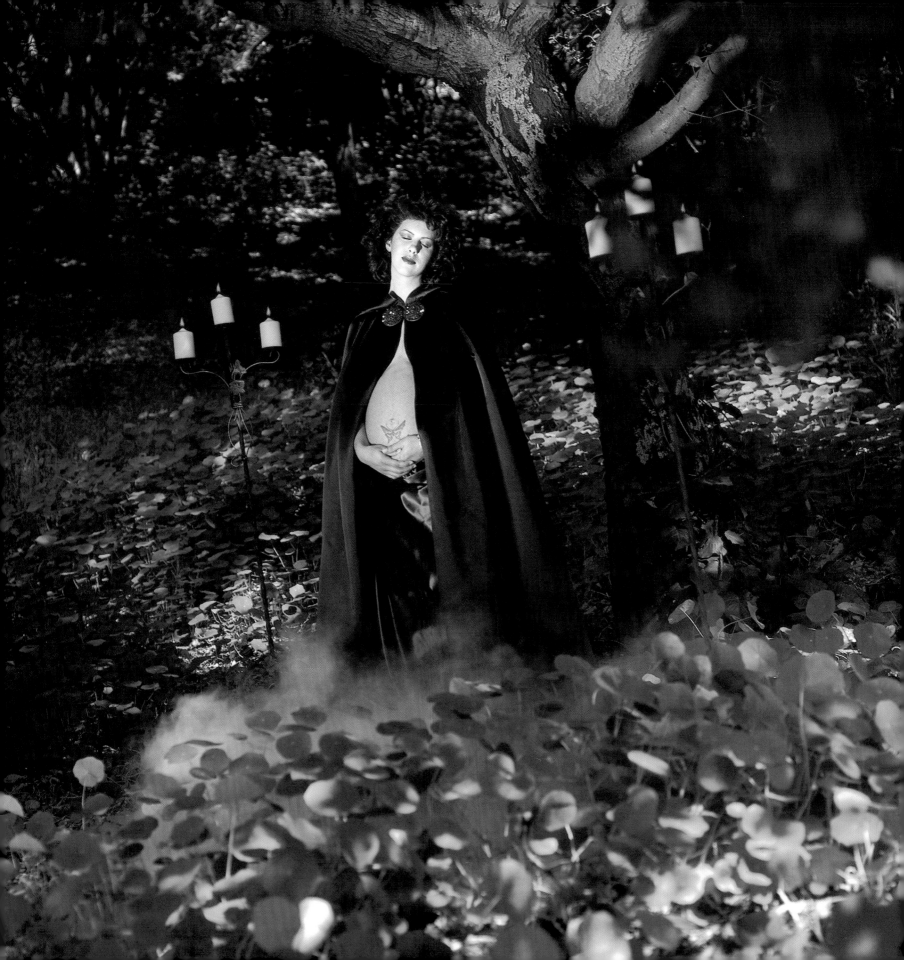

Jennifer Christie

My husband, Marc, and I tried for a year before I got pregnant. In that year's time, I had imagined over and over

what it would be like. Yet when the doctor confirmed that I was indeed pregnant, my feelings were nothing like I had thought they

would be. I was feeling things that were indescribable—the amount of love, joy, anticipation, and fear were beyond belief.

It was the same way giving birth and having a child in my life. I once again had tried to imagine what these would be like,

and once again, they ended up being beyond my imaginings. Each day with our son Jacob is such a learning experience.

Each day is filled with more love, joy, and anticipation—and some fear.

One of my favorite things that Jacob does is open his mouth and stick out his tongue, just slightly, when he is hungry.

It reminds me of a little bird.

We love you, Jacob.

~

Jacob Michael

Born May 2, 1997

Darcy Lee Walters

Once a "showgirl," always a "showgirl." But now, I'm facing the beautiful challenge

of adding a few more feathers to my headdress. To shift my focus from a life thus far about self-expression

to the special being I have been assigned to. This will take the fanciest footwork yet! To raise my son with time,

patience, and intuition. Making sure to nourish, protect, cherish, and support.

But what about all those exciting numbers just waiting to be performed?

Lullabies and fishnets…do they go?

~

Expecting a boy…

Due September 14, 1997

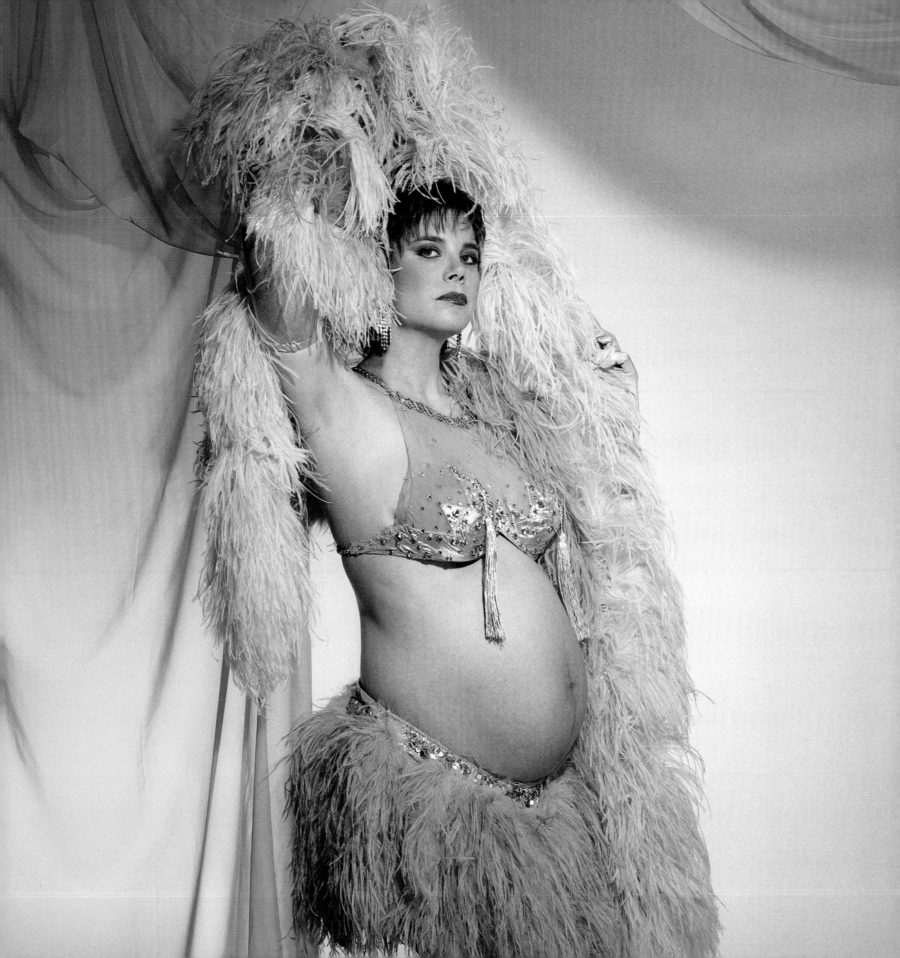

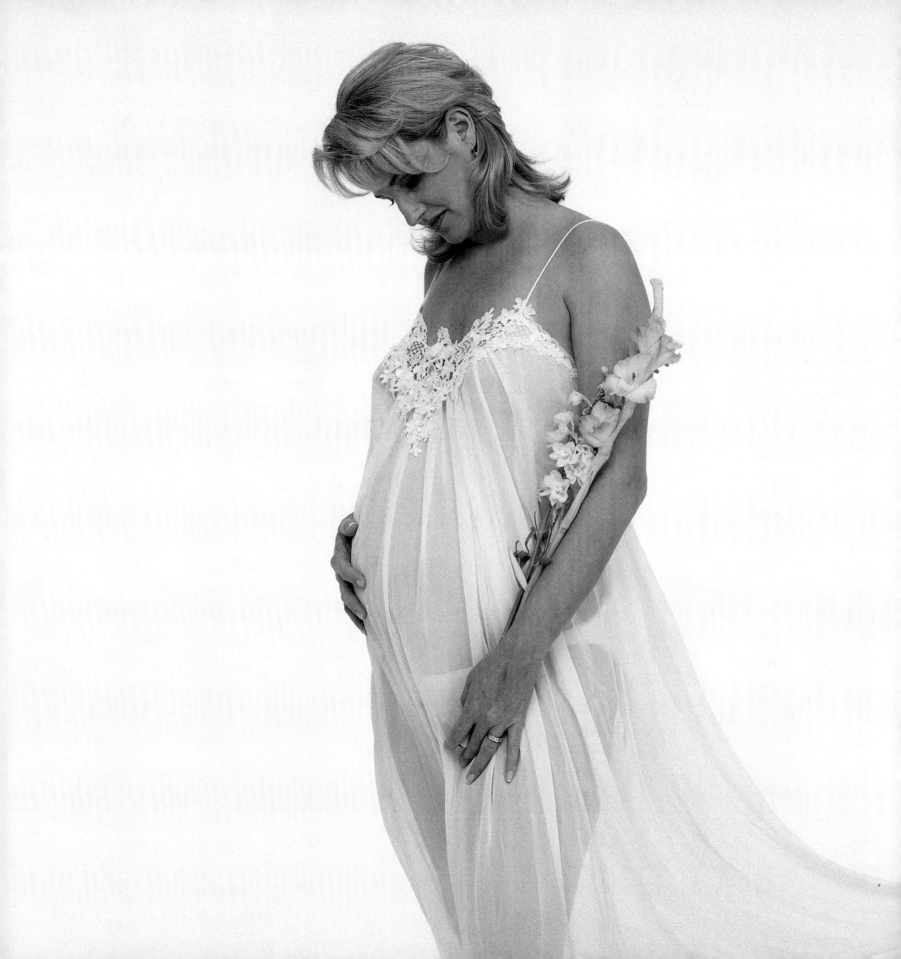

Elizabeth Nyman

I truly would not have understood the purity of love without this wondrous miracle I am experiencing…life within life. What a

powerful feeling. The joy and excitement I feel transcend words.

Your daddy and I can't wait to meet our beautiful baby girl.

~

Kaitlyn Sara

Born October 14, 1996

Lori Peters

I had to cry today. I was so ashamed of myself. I was complaining about how hot I was, how strong your kicks have become,

how I can't sleep with this awesome weight in my belly, my face breaking out because of the hormones.

Then I caught myself. I had forgotten what a miracle you are. How much I wanted you in the first place.

How I longed to carry this pregnancy to term. Here I am in my ninth month, finally, my dream come true —

and for a moment I'd forgotten what a gift I've been given.

~

Charlotte Ann

Born May 23, 1996

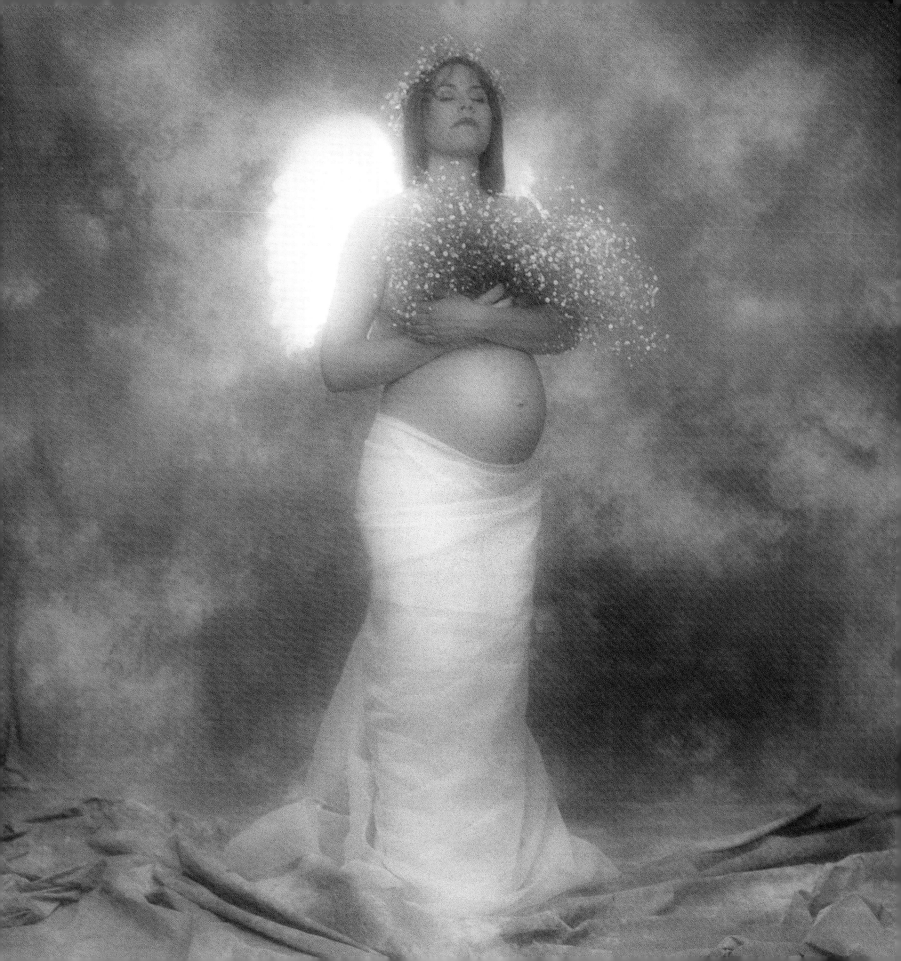

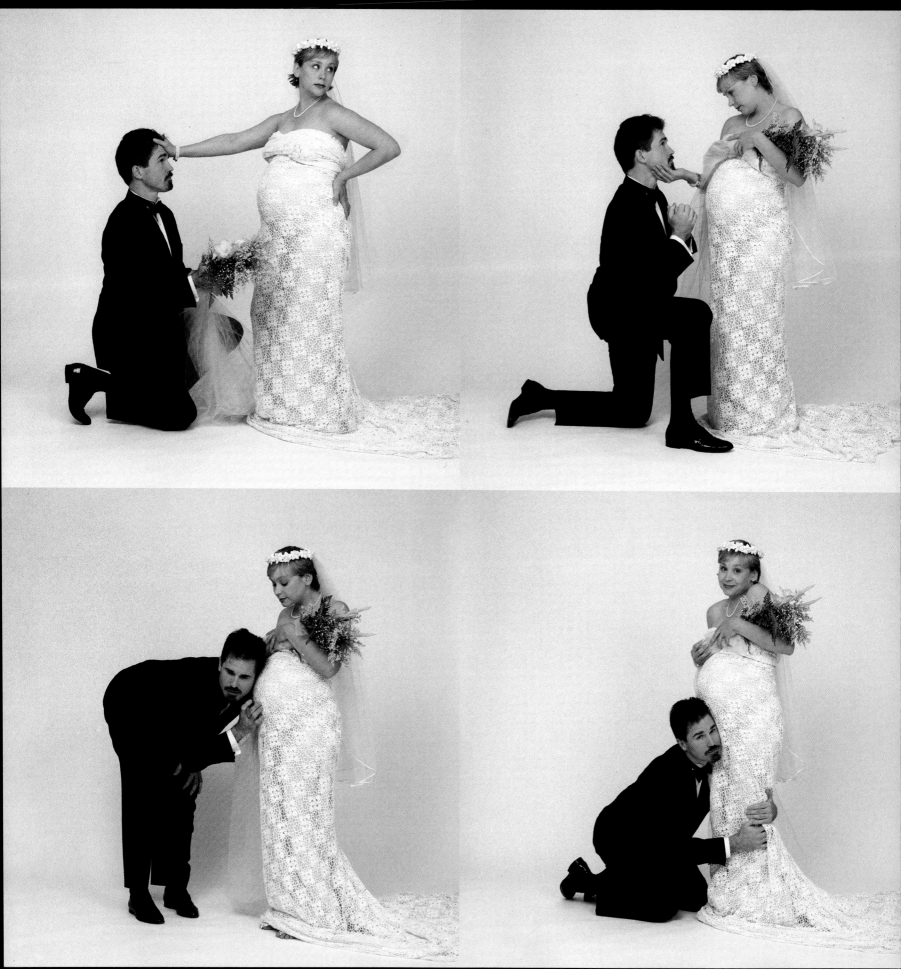

Mai Lis Miller

Pink strip turning blue, toes curled in bathroom, what to do? Feeling nauseous, thanks for the towel, dogs look worried, so do you.

Find a doctor, did you like her, NO. Feeling nauseous, thanks for the towel, dogs look worried, so do you. Find a doctor,

did you like her, yellow tiger print stockings, wow, I like her. Feeling nauseous, where's my towel, where are the dogs, where are you?

Tiny heartbeat, beating fast, size of a paper clip, halfway there. I feel better, clothes don't fit, big jean muumuu, shoes don't fit.

Something might be wrong! Something might not be right! To the hospital. A talk, a test, a needle. Small screen project,

baby swimming round, spine looks strong, heart beats fast. Do you see that, do you want to know, yes I do, he's a boy.

Daddy sits down, Daddy looks pale, now Daddy is nauseous, see how it feels. Waiting forever, did the phone ring?

Counting 10 working days, I feel sick again. Finally news, nothing is wrong, everything is right, do you like blue?

Do you like the name Larkin, that sounds perfect, different, but not perfect. Gaining weight, eating pizza, 49 extra pounds,

am I as big as I sound? He's never coming, not ready to come out, where are you already, we've been waiting for you.

Seafood dinner, glass of wine, ouch strong kick, or was it your behind? Ouch long night, ouch you slept? Ouch let's go,

ouch long check-in. Hours and hours, Demerol haze. Hours and hours, I'm still in pain. Epidural, epidural, where have you been,

epidural, epidural, without you I won't do this again. Time to push, can't feel my legs, he sees his head, just look at me.

Hand held tightly, steady breaths, stay with me, soon to be there.

~

Larkin Eric

Born August 24, 1996

Jill Engels

As this was my second pregnancy, the immense mind- and body-bending physical changes I went through

were not as frightening but still wondrous.

As my first son instinctively became more clingy as the big birthday neared,

we wondered if there would be enough love for two. With all the absolute attention we lavished on the first child,

would there be enough holding, snuggling, laughing, crying, and eye-to-eye, face-to-face moments in a day? For two?

Of course, we discovered an embarrassment of riches and learned that love can grow exponentially.

And now we find delightful music in our very happy quartet.

~

Archer Mailand

Born September 28, 1995

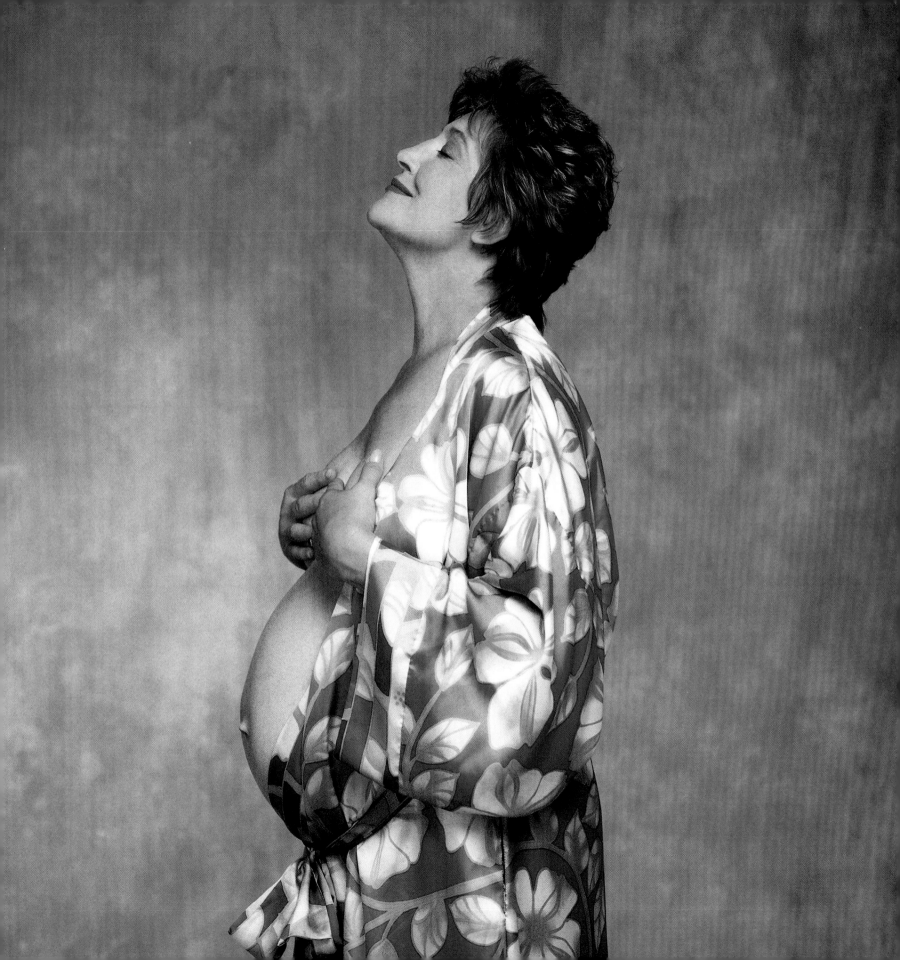

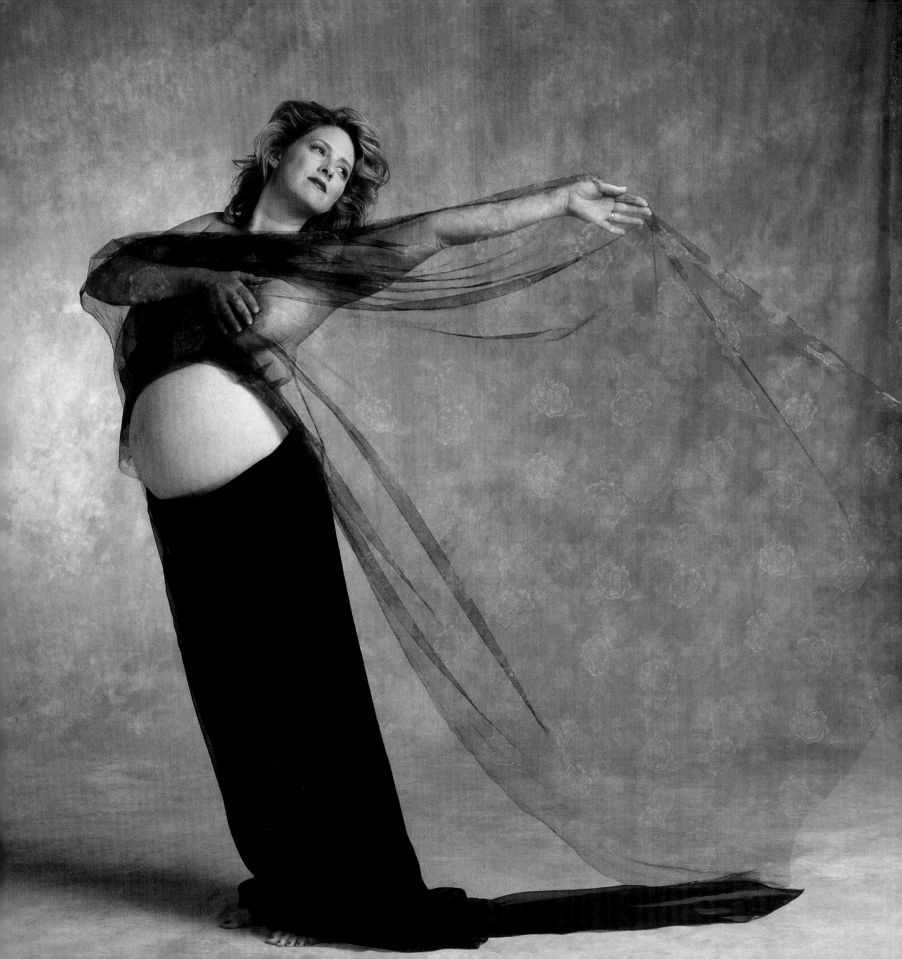

Beth Taylor Hart

I was raised one of eight children and always knew without a doubt that I wanted to have a child of my own.

Even after I married, I felt my world was uncomfortably quiet and predictable. Holidays were odd to me.

But at 38, I had no idea how the experience would alter my entire perspective on life and loving.

You think you know love—you love your husband, your family, and even your pets. Then along comes this little person, and your capacity for love is expanded beyond belief. To think I could have lived and never known this powerful, awesome, undeniable love. Thank you, Emma.

~

Emma Kathrine

Born October 20, 1995

Spice Williams

The fear of having a child always tormented me, but I knew, deep down, someday I would succumb to the idea.
Now that I think back, my worries were dictated by fear instead of love—fear of not being able to work, getting fat, losing touch
with my business, not knowing anything about children, and hating cartoons.

When my best friend, Pat Tallman, got pregnant, it hit me like a ton of bricks: it's now or never, Spice!
This is the right time to have a baby. If she can do it, so can I.

Three months later, I learned I was having twins. I decided I would make this the biggest production of my life.
I trained two hours a day. Being a strict vegetarian (vegan), I carefully monitored my protein, carbohydrate, and fat intake.
By my third month, one of my twins, termed a "phantom twin," was beginning to dissolve. I cried for 30 minutes,
until I felt OK with the hand life was dealing me. In retrospect, I was probably relieved.

From then on, I felt I was part of a miracle about to happen. The power I experienced was almost godlike—
as if I were the incubator for an incredible spirit about to come into this dimension,
and it was my responsibility to prepare its journey and new home.

The trip to the birthing center was definitely a trip and a half! What a weird sensation knowing that after experiencing
unbelievable pain, I would give birth to a soul who would change our lives forever.
Fourteen hours later, Luke was in my arms, and it was love at first sight.

I cry more now and feel deeper about anything that has to do with children.
Oh, and yes, my favorite movies are Winnie the Pooh, Snow White, Dumbo, The Aristocats, and The Lion King.

Luke definitely lit up our lives!

~

Luke Gregory
Born February 1, 1996

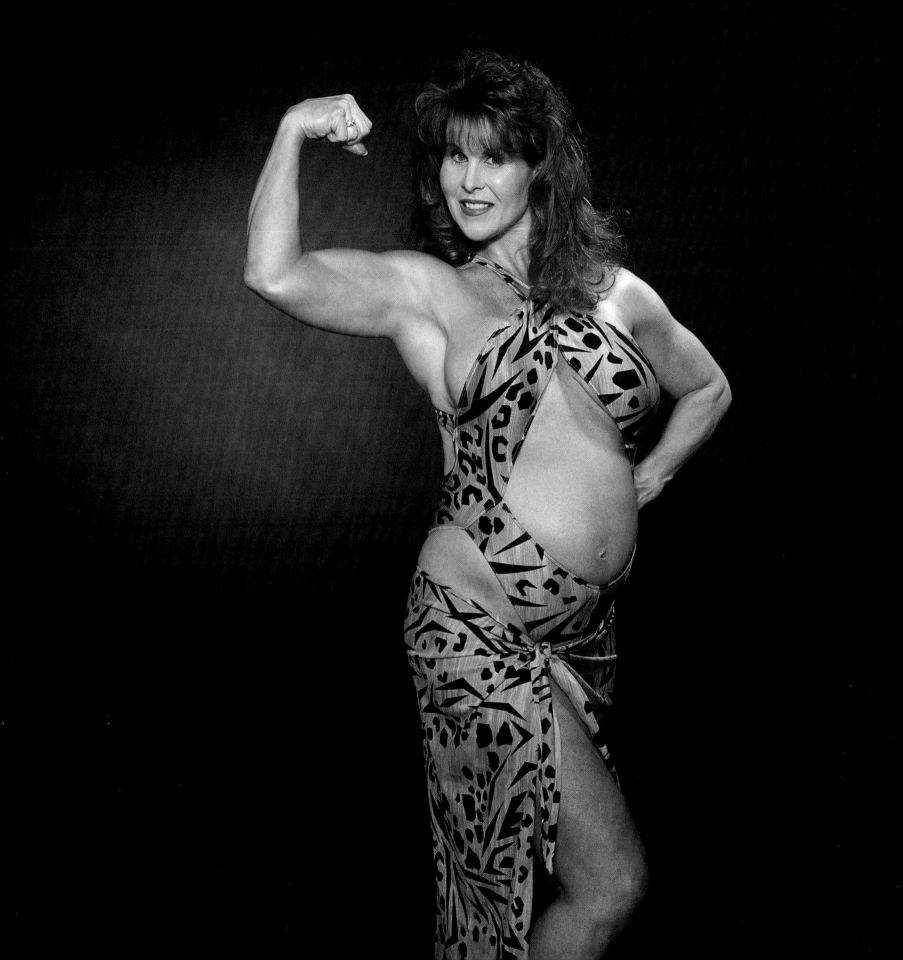

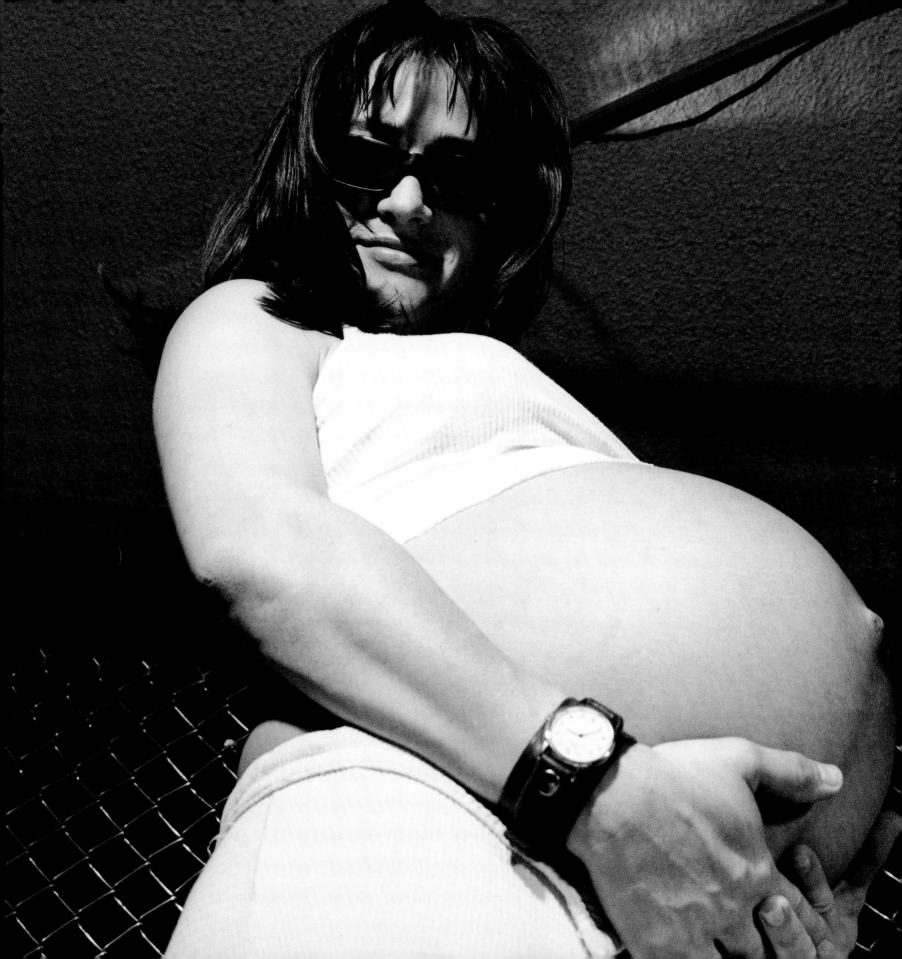

Pamela Segall Adlon

march 25, 1997

Hello Kid Butterfly inside me,.......Dear Little Body Snatcher,..............

My Dearest Buddy Baby Alive and Squiggly........Baby Love Bubby Dove......

Hello conqueror of the future. This is your host organism speaking. Freaking.

"how long?" "3 minutes." ding!

and then, You Baby, sent up a signal flare in the form of a red stripe on a white plastic stick

omigod omigod omigod

"HONEY!"

He came in—checked out your salutation—followed me softly—sat with me on the deck—

(final destination of your conception wouldn't you know)—looked over at me—

and Smiled.

I know what happened.

We (your mom and dad, omiGOD!) loved each other so fast, so hard, and so much,

that it just had to spill out and over and come together and create————YOU.

april 8, 1997

Now that the unbelievable has transpired I can tell you this is too stratospherically amazing.

Better than a miracle. Evidence

of impossible's losing their im's

Martians landing in my driveway

the rain forests growing back

automatic weapons a bad memory

and food and love for every body.

It could happen.

~

Gideon Don

Born March 30, 1997

Cindy Raposa

It was a miracle I got pregnant in the first place. It's a miracle for any of us.

This is how I pictured my pregnancy: serene, beautiful, and enjoying my child. But that is not how my doctors and the State of California pictured it. They pictured me working behind a bar, reaching, lifting, getting pushed, my stomach being bruised by bottles, and standing on my feet for 8-10 hours straight. Along with getting migraines every two days.

Considering that I have gestational diabetes, I'm 45 years old, I've had five miscarriages, and I just plain couldn't fit behind the bar, I found it absurd that my doctors would have me work under such conditions until I delivered.

All I wanted to do was be with my child, nurture my baby, and enjoy my pregnancy. Fortunately, my employers understood what my doctors didn't and laid me off.

The State allows pregnant women to collect disability starting only four weeks before their delivery date, no matter their job. I was out of the hospital in 24 hours. I'm to be back at work in six weeks. It's very scary how the "World's Greatest Nation" takes "uncare" of its families.

Of course, I have a beautiful baby boy. Was it worth it? Yes, but it really was "the best of the worst of times."

~

Lucas Dominic

Born July 22, 1996

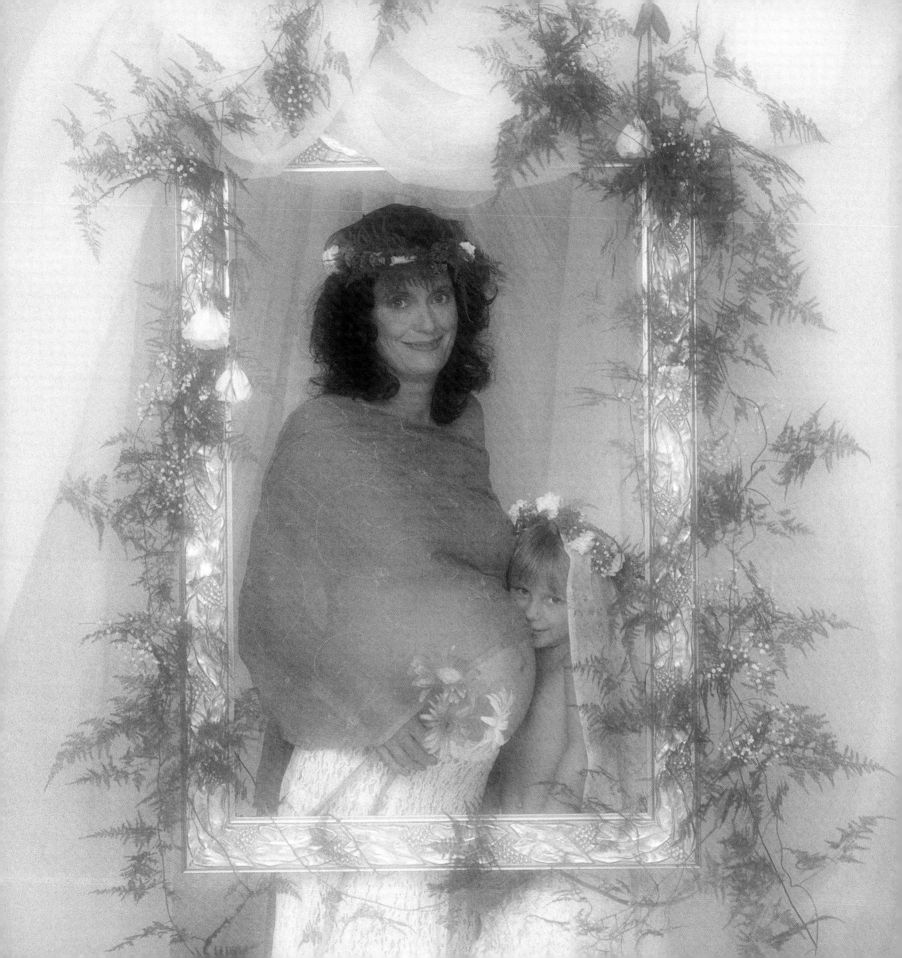

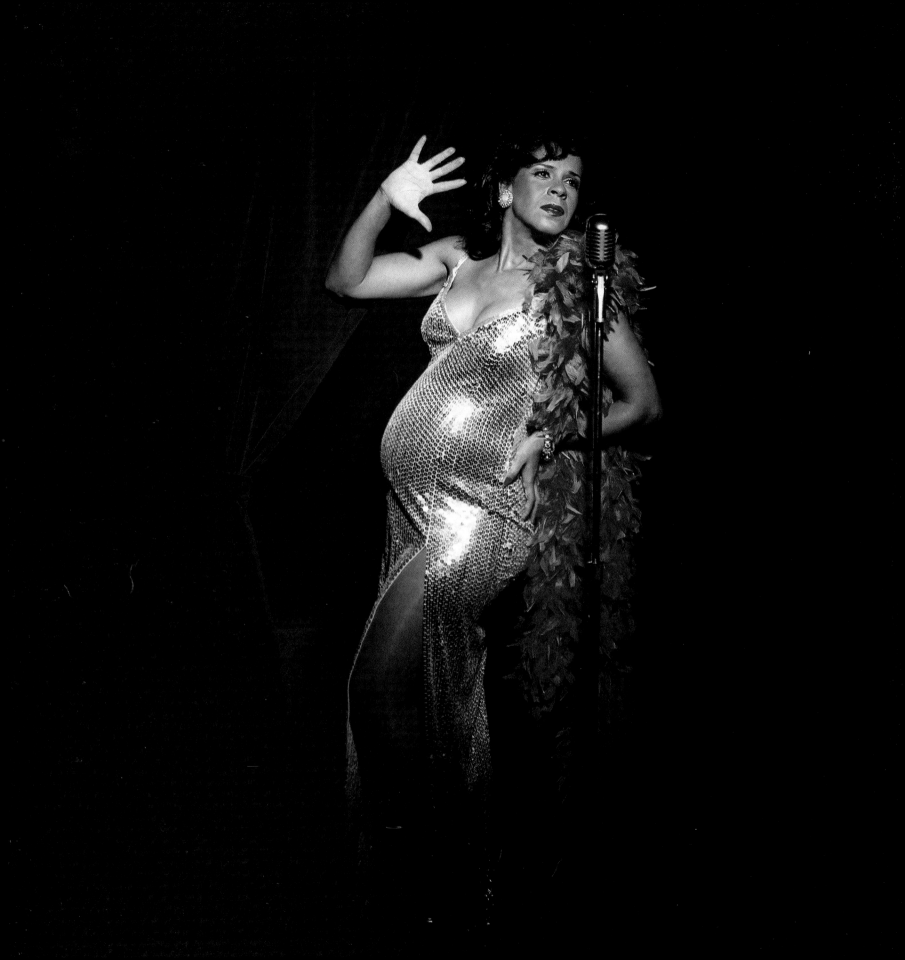

Hollis Payseur Polito

I sing, I dance, I travel…and I love it! But nothing compares to being pregnant…nothing!

I LOVED BEING PREGNANT! Being pregnant was the most beautiful, wonderful, special, interesting, and spiritual time of my life. I was effervescent, filled with bliss, and undeniably proud. I glowed inside and out (and it wasn't the sequins). I tingled. I sang notes that were out of my range. And I danced well—in four-inch heels for eight-plus months. Our audiences all over the world were amazed. I was amazed.

Our child was surrounded by music from day one. Whether rock, jazz, or classical, it was in the air. He was conceived, from our hearts, in the heart of Piccadilly Circus, London, England, during a month-long engagement there. It wasn't until I had been scheduled for a three-week performance on a cruise ship from Singapore to Thailand that he started kicking. In the following weeks, the kicks got more "playful." He hiccuped during an entire tour through Paris and parts of Germany.

I carried him around the world before he was delivered into this world. With his "experience" going from venue to venue, from city to city, from one end of the globe to the other, it would not surprise me in the least if his first words were "So, what time is the sound check?"

~

Ryan Fox

Born November 25, 1995

Isabel Lepejian

Two people with very different minds

Two people with very common goals

Two people who vow to unite

Two people who create one family

Two people who have so much love to give

Two people who pray for what no money can buy

Two people who experience divine creation

Two people who are now three —

Three people that rejoice in each other

Three people who experience new life everyday

Three people who grow together

Three people who started as two.

~

Talia

Born January 18, 1996

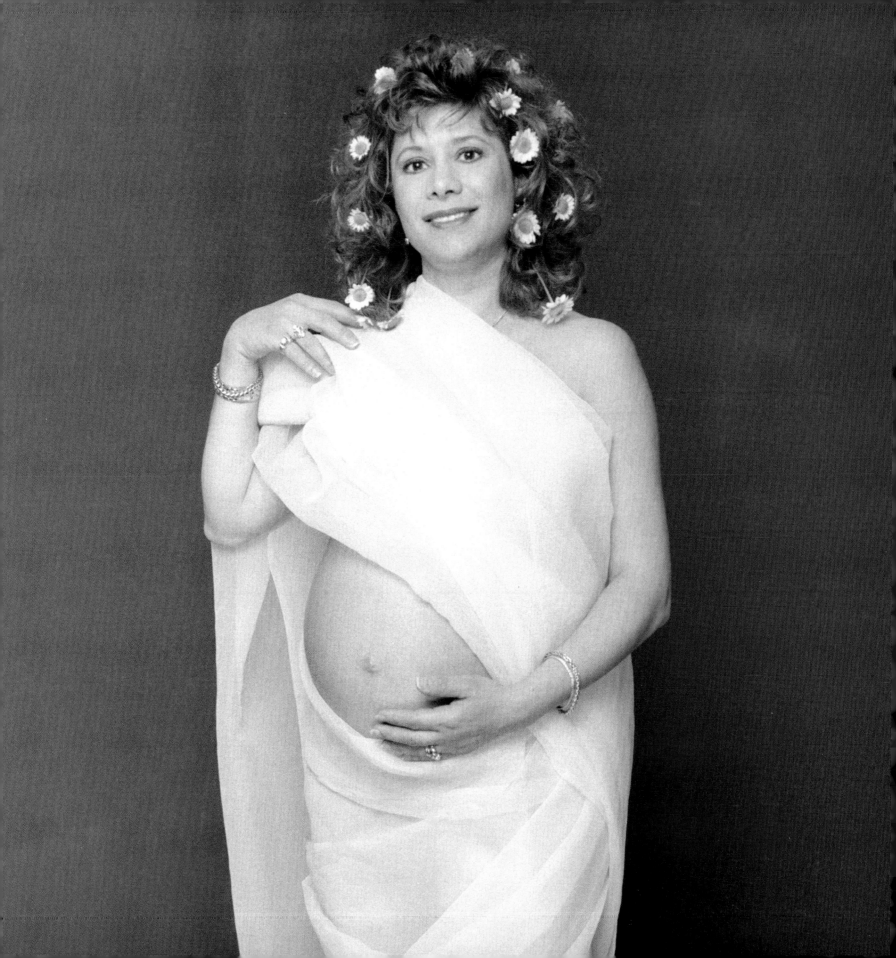

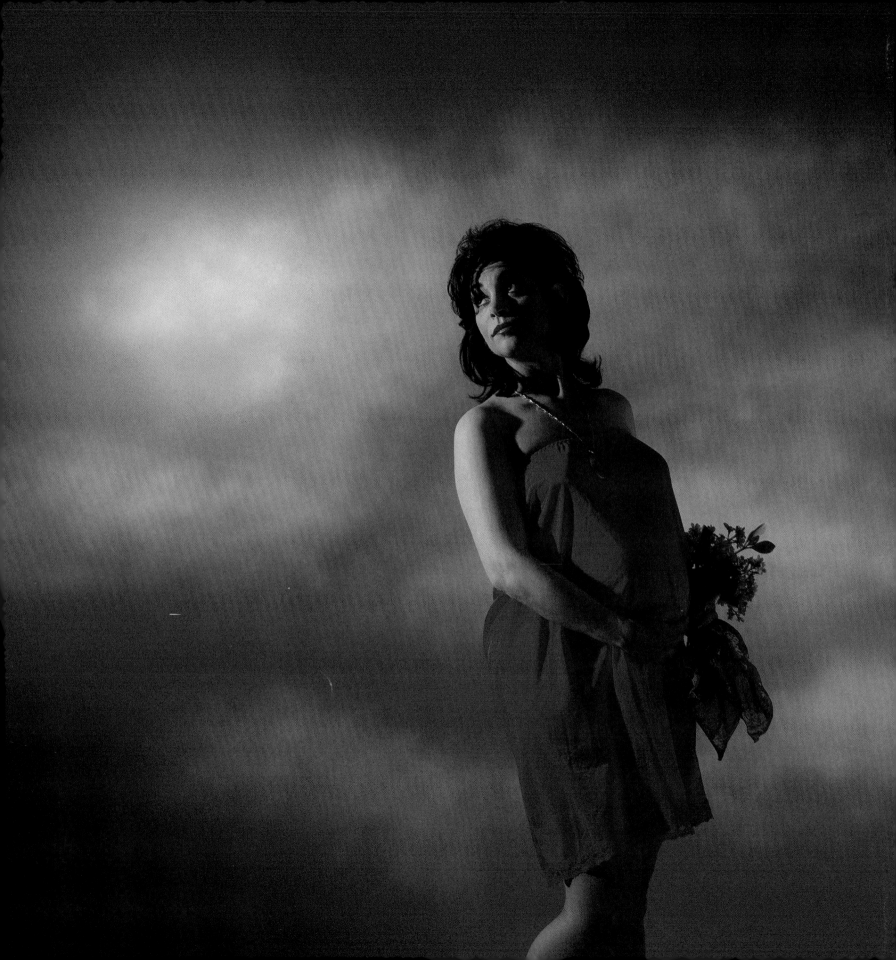

Terri Recchia

During my pregnancy, I was confined to three months' bed rest after experiencing preterm labor.

Fear and shock overwhelmed me; however, this period brought greater intimacy to my pregnancy

and emotional preparation for our son.

As someone so very special would be entering our lives,

someone equally as special to me passed away—my grandmother.

Such permanence in both cases: a new breath of life, a human legacy, a joy where sorrow began.

My grandmother always cooked chicken with the crumbs;

she also dressed with a slip pulled above her chest—that was her trademark!

The broach, which has my picture in it, was given to her by my mother in 1965.

She passed away just prior to our baby's birth.

~

Jared Harrison

Born April 9, 1997

Pat Tallman

My pregnancy was unplanned. I was at the peak of my stunt career, working consistently on big projects. Being in our business means being very aware of your body. To surrender to the changes in my body was one of the most painful things I have ever had to do.

While pregnant, I maintained a schedule of working out five days a week—kickboxing, running, rollerblading 26 miles at the beach every Saturday—continued to eat carefully, and still watched my weight climb. Many times in the gym I'd sob in frustration as I struggled for the energy to get through a workout and saw evidence of my hugely blooming condition in every mirror in the room. I never considered dieting or depriving my growing child of calories, but I couldn't accept my weight and inch gain when women with no training schedule possessed shapely legs and tiny butts. Gradually, as my focus shifted inward to my wiggling little boy, my butt mattered less.

I continued to be amazed at how large I was growing and was convinced the baby would weigh 20 lbs. I was too tired to care! Eventually, I decided to document the amazing changes in my body—being 37 years old, I wasn't sure they would happen again!

I no longer have the body I had before Julian was conceived but feel beautiful and womanly anyway. I won't ever be the same mentally or spiritually, so why should I be the same physically? I am no stranger to taking risks if I think something is worth it. No one could have told me what an incredible journey this pregnancy would be for me, in a healing way. No one can prepare you for the adventure life offers you, because they are not you. They can only support the process and tell you that you are beautiful until you believe it.

~

Julian Jon

Born November 12, 1994

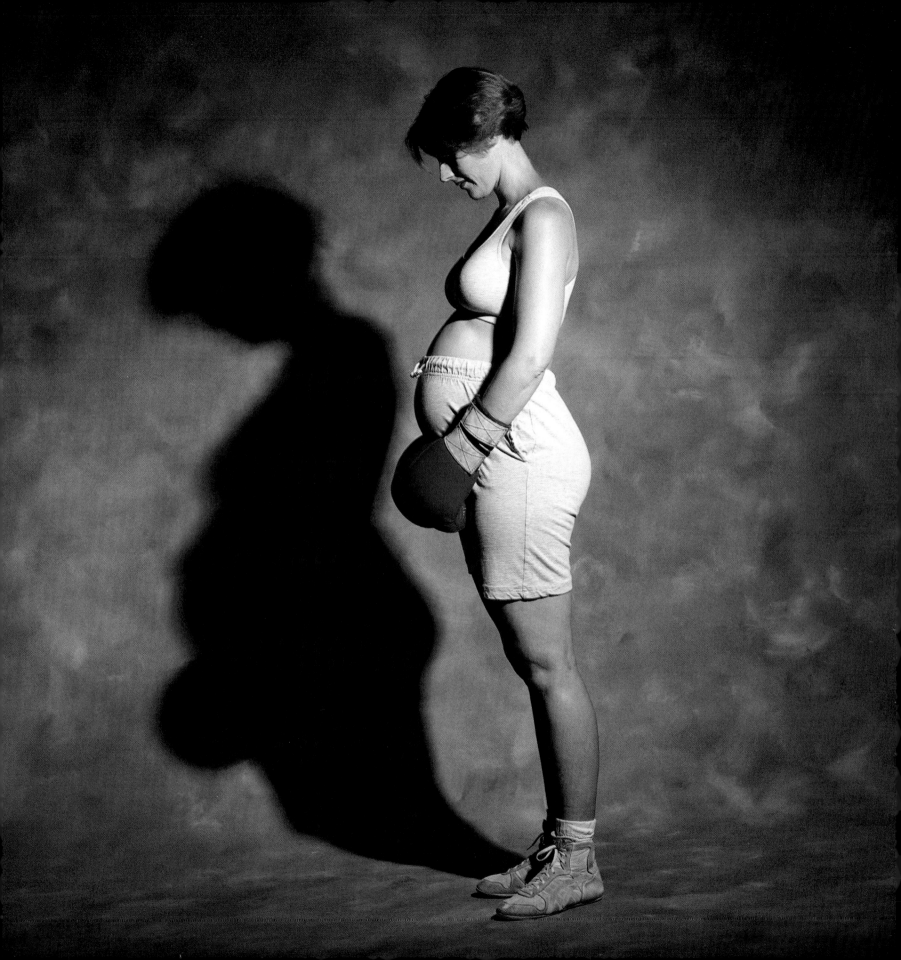

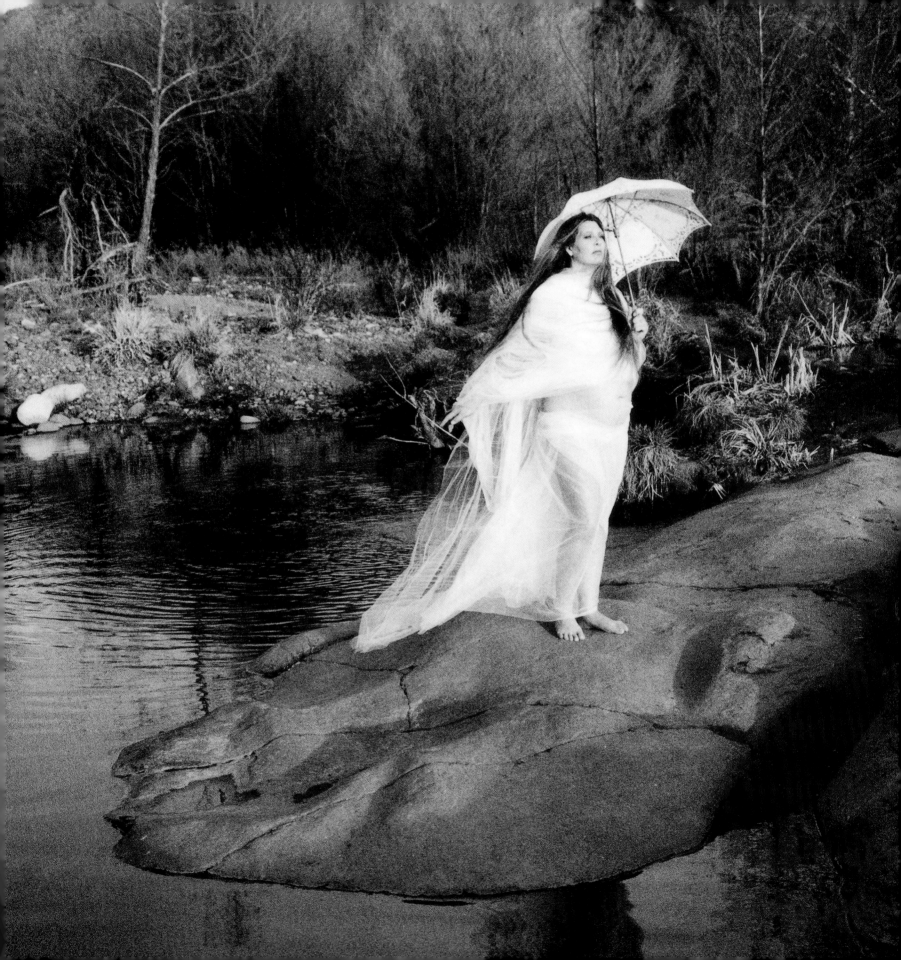

Lisa Schultz

Being the busy person I am, both attending school and working full-time while raising my teenage daughter,

finding out I was pregnant again was almost more than I could bear. How could I possibly find the time to raise another child?

Then my son was born. A surge of absolute love washed away all my fears. This baby made me realize

that there is nothing more important in the world than slowing down enough to enjoy my life with my children.

Now the life I lead continues to be full, working and studying as I still do, and I have never been so content.

~

Nicholas

Born June 12, 1996

Sabrina Won

Dear baby,

First you made me happy, then you made me sick. You made me tired. You made me excited.

You made me very, very uncomfortable. You made me proud. The happiness I felt about you never went away—

it just took a backseat to some other symptoms.

From the beginning, my sleep was interrupted. I had insomnia, so I was always tired.

When I did sleep, I had some pretty bizarre dreams.

My first trimester was the worst. I was extremely sick for almost a full three months.

I was throwing up about three times every single day and feeling sick 24 hours a day. Nothing eased the nausea. Nothing!

The only thing that kept me from going crazy was the fact that there was this little miracle from God growing inside me.

When I heard your heart beat for the first time, I instantly forgot how sick I felt and wanted to cry for joy.

Every time I heard your heart beat, I couldn't wipe the smile off of my face. It was like hearing it for the first time, every time.

By the end of my first trimester, I started feeling better. It was wonderful.

Being able to get around and do something made me so much happier.

Feeling you move inside me all the way to the end was the most incredible experience. The bigger and stronger you got,

the more intense the feeling. With only a couple of weeks left, and all the accompanying discomfort,

I still found you extremely precious. I couldn't wait to see you, to hold you, to smell you.

Having a brand-new life grow inside me was very hard, but I did it, and I am very proud.

~

Jayna Yong Joo

Born May 9, 1997

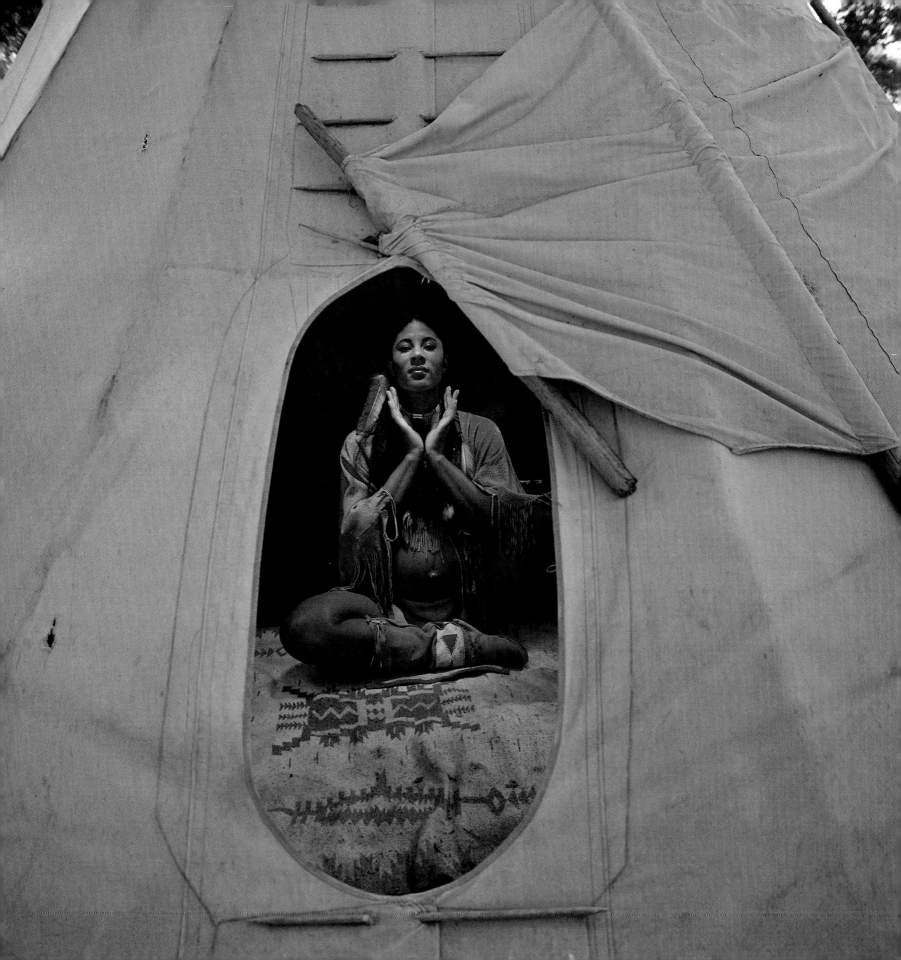

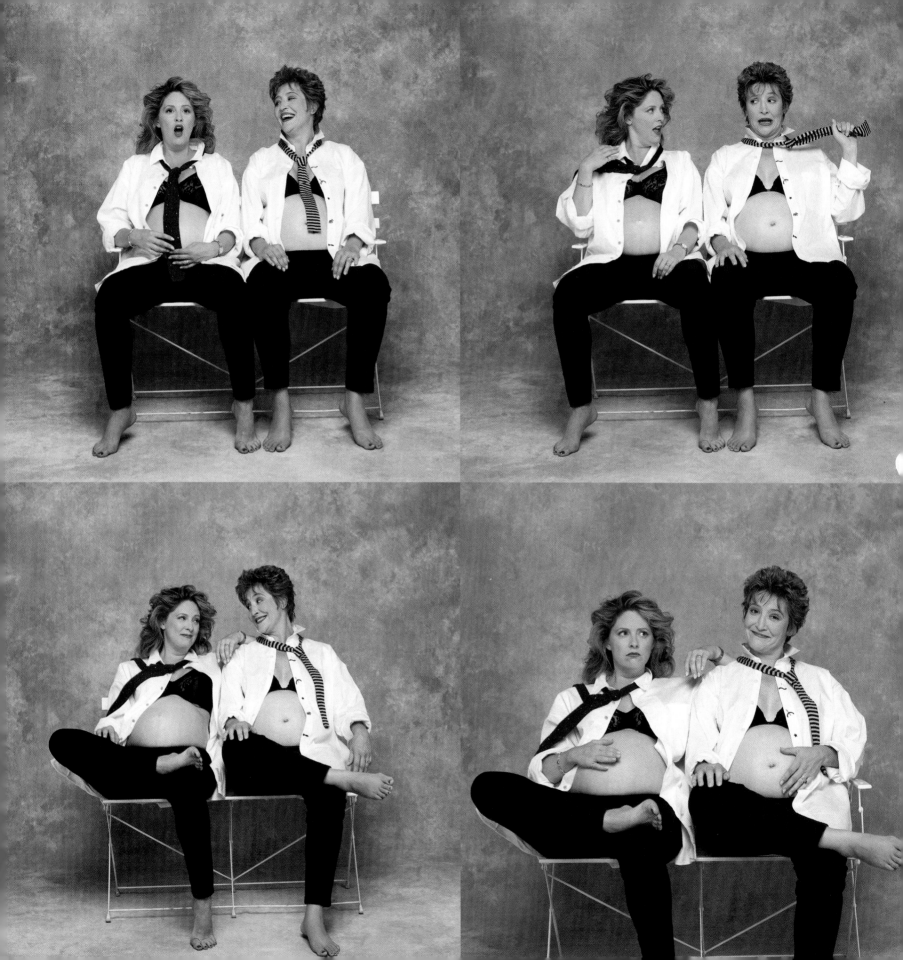

Friends

Whenever Beth and I meet for lunch, we always reserve a table for four.

~

Beth Taylor Hart, mother

Emma Kathrine, child

Born October 20, 1995

~

Jill Engels, mother

Archer Mailand, child

Born Sepember 28, 1995

LEFT TO RIGHT:

ARNIE WOHL, FATHER
RACHEL, CHILD

ARTHUR MORTELL, FATHER
DASHIELL, CHILD

WILLIAM BOOTH, FATHER
LIAM, CHILD

DRAGAN BUHA, FATHER
NIKOLAS, CHILD

DAVID COOKE, FATHER
JULIA AND RILEY,
CHILDREN

CHRISTOPHER ENGLISH,
FATHER
RYAN AND BRIANA,
CHILDREN

FELIX ADLON, FATHER
GIDEON, CHILD

BOB ENGELS, FATHER
ARCHER AND SULLIVAN,
CHILDREN

QUAY HAYS, FATHER
PIPER, CHILD

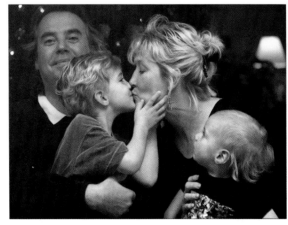
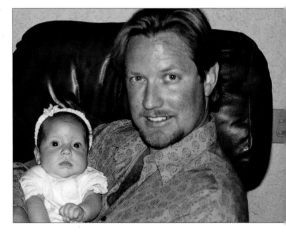

ANDREA ROGANTINI,
FATHER
JULIAN, CHILD

WILLIE ETRA, FATHER
ANNAROSE, CHILD

CHRIS HART, FATHER
EMMA, CHILD

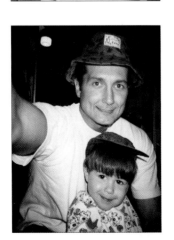
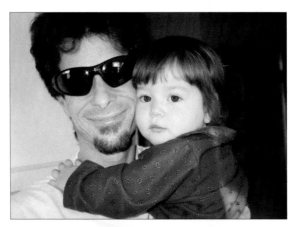
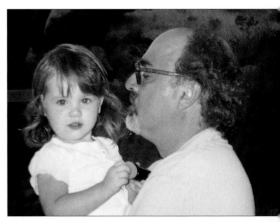

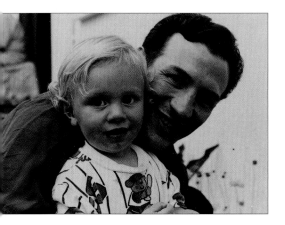
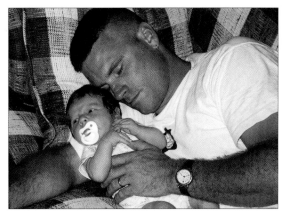
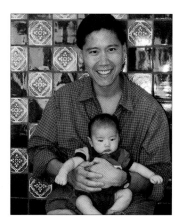

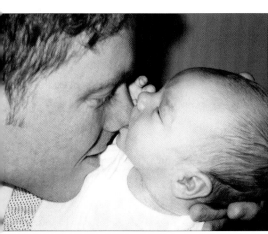
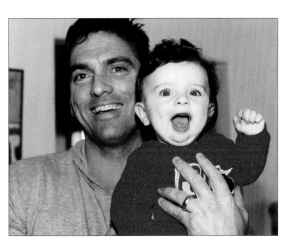
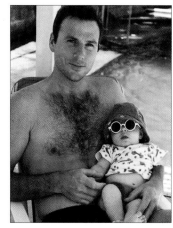

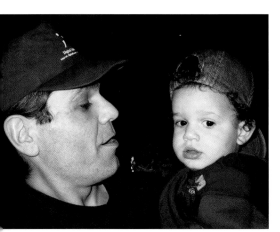
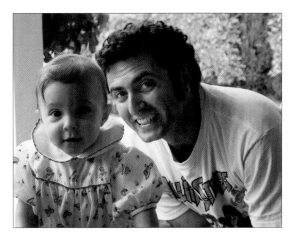
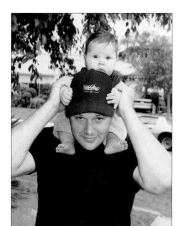

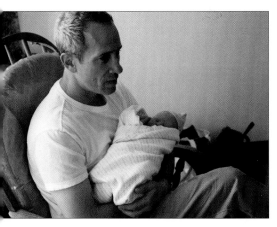

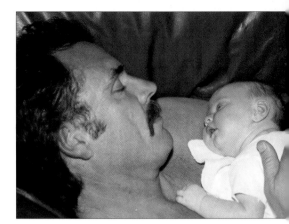

LEFT TO RIGHT:

MARK PIERSON, FATHER
SADIE, CHILD

NEIL ROSS, FATHER
DANIELLE, CHILD

KEN RADCLIFFE, FATHER
REMINGTON, CHILD

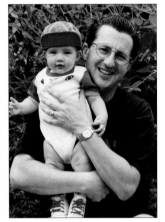

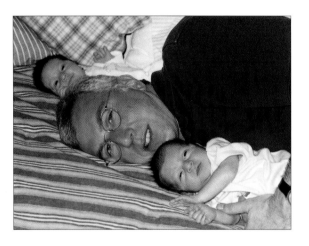

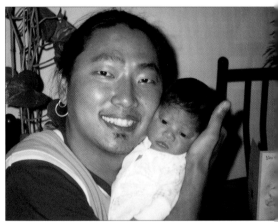

KEITH MACKECKNIE,
FATHER
COLLIN, CHILD

ANDY SOMERS, FATHER
SASHA AND NOAH,
CHILDREN

JAYSON WON, FATHER
JAYNA, CHILD

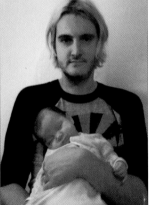

SCOTT TRACY, FATHER
CHLOE, CHILD

RICHARD RAPOSA, FATHER
LUCAS, CHILD

CHRISTIAN MILLER,
FATHER
LARKIN, CHILD

MICHAEL LASTING, FATHER
LIAM, CHILD

MARC ETTLINGER, FATHER
JULIA AND JACK,
CHILDREN

MARK MIHANOVIC, FATHER
JOSEPH, CHILD

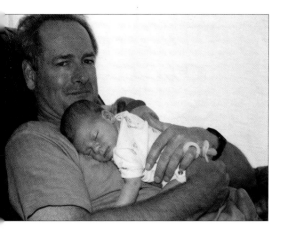
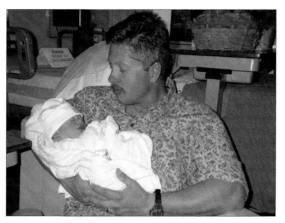
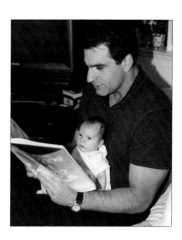

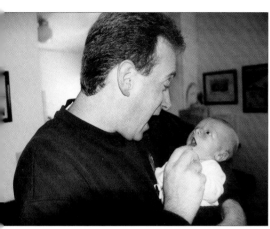

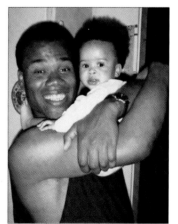

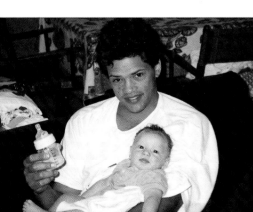
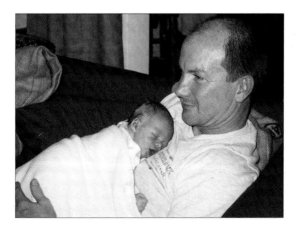
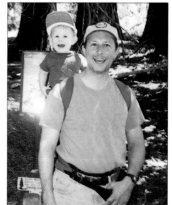

The Goddess Moms Recommend...

From Here to Maternity, by Connie Marshall, R.N. (Prima)

Meditations for New Mothers, by Beth Wilson Saavedra (Workman)

Operating Instructions, by Annie Lamott (Valentine Fawcett)

Pregnancy and Birth Book, by Dr. Miriam Stoppard (Valentine Fawcett)

Spiritual Parenting, by Hugh & Gayle Prather (Random House)

The Breast Book, by Dr. Miriam Stoppard (D.K.)

The Complete Single Mother, by Andrea Engber & Leah Klungness, Ph.D. (Bob Adams, Inc.)

The Girlfriends' Guide to Pregnancy, by Vicki Iovine (Pocketbook)

The Pregnant Woman's Comfort Book, by Jennifer Louden (HarperCollins)

The Well Pregnancy Book, by Mike Samuels, M.D., & Nancy Samuels (Simon & Schuster)

What to Expect the First Year, by Arlene Eisenberg, Heidi E. Murkoff
& Sandee E. Hathaway, B.S.N. (Workman)

What to Expect When You're Expecting, by Arlene Eisenberg, Heidi E. Murkoff,
& Sandee E. Hathaway, B.S.N. (Workman)

Your Pregnancy Week by Week, by Glade B. Curtis (Fisher)

Sources and Hotlines

American College of Nurse Midwives: *For midwifery practices in your area and for information on nurse midwives, home birthing, birthing centers, and centuries-old birthing techniques: 888-MIDWIFE [643-9433]; Website: www.midwife.org.*

The Bradley Method of Natural Childbirth: *For information on the Bradley Method and directory of instructors: (800) 422-4784.*

Immunization National Hotline: *For information on the recommended childhood immunization schedule in your area: (800) 232-2522 (English) / (800) 232-0233 (Spanish).*

La Leche: *For information on breast-feeding and representatives in your area: (800) 525-3243.*

National Hotline for Pregnant Women: *For information on prenatal care, including finding a health care provider and paying medical bills: (800) 311-BABY [2229].*

Project Cuddle: *A confidential nonprofit organization providing a future for drug-exposed babies and children in crisis. Founder Debbie Magnusen is the parent of seven children, five of whom are adopted: 88-TO-CUDDLE [888-628-3353]; Baby Hotline (714) 432-9681. Donations of time or money.*

Sidelines: *Offers support to women with complicated pregnancies, matching high-risk mothers across the country with a trained volunteer who has experienced a similar pregnancy: (714) 497-2265; e-mail: sidelines@earthlink.net / Website: www.earthlink.net/~sidelines.*

Magical Beginnings, Enchanted Lives: *A Chopra Center program that educates expectant parents in holistic pre- and postnatal care: (619) 551-7788 / (888) 424-6772.*

About the
Edwarda O'Bara Fund

At the age of 16, Edwarda O'Bara lapsed into a diabetic coma. Her last request to her mother, Kay, was to promise never to leave her. In response, Kay's final words to Edwarda were "I will never leave your side, Edwarda. A promise is a promise."

Edwarda has remained in a coma for 27 years. Kay has kept her promise. Only a heart attack interrupted her vigil, for a total of 10 days.

The experience of Edwarda's coma and Kay's unconditional mother's love has touched the hearts of people all over the world. Oprah Winfrey has featured Kay and Edwarda on her show. During Pope John Paul II's visit to the United States, he contacted them to visit their home and administer a blessing on Edwarda. A book titled A Promise Is a Promise by Dr. Wayne Dyer and his wife, Marcelene, was released in September 1996. All proceeds from that book are earmarked for the Edwarda O'Bara Fund.

Kay explains that she believes Edwarda is a "victim soul" and the reason she is in a coma is to help touch and transform people's lives. Both mother and daughter have done just that. Kay has faith that Edwarda will come out of her coma soon and that day by day she is approaching consciousness.

Kay has struggled financially to keep her promise. Although she is deeply in debt, she has never asked money from anyone. Nevertheless, people worldwide are drawn to help support her.

A portion of the royalties of this book are designated for the Edwarda O'Bara Fund.

~

Send any donations to:

Edwarda O'Bara Fund

P.O. Box 693482

Miami, FL 33269-3482.